The
Watercolor
Fix-It Book

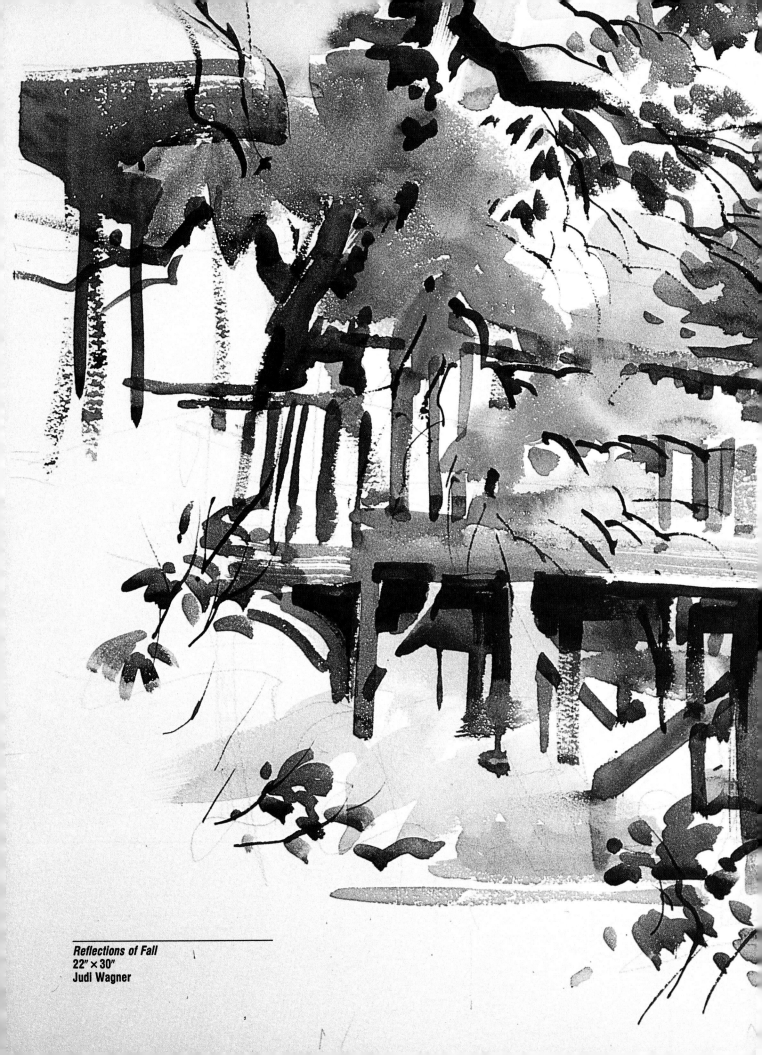

Reflections of Fall
22″ × 30″
Judi Wagner

The Watercolor Fix-It Book

Judi Wagner
and
Tony van Hasselt, a.w.s.

NORTH LIGHT BOOKS

Cincinnati, Ohio

About the Authors

After twenty years of conducting workshops throughout the country and abroad, Judi and Tony thoroughly enjoy working in and around their summer studio on Linekin Bay in Maine, and their winter studio on Florida's Amelia Island. Though they continue to teach through books and videos, they now limit their workshops to just two a year, at both the Maine and Florida painting locations. Recently, their work has been featured in Ron Ranson's popular book, *Watercolor Impressionists*, available through North Light.

Judi Wagner earned her Bachelor of Fine Arts from Parsons School of Design and her Masters degree from Parsons and Bank Street College of Education. In addition, she studied with well-known painters such as John Pike and Edgar A. Whitney. Her background includes graphic design, theater design and printmaking. Judi has taught her own workshops in the U.S., and has also conducted summer programs for Parsons School of Design in France and Italy. Her work has been exhibited in the annual shows of the American Watercolor Society, the Audubon Artists and the National Arts Club and Salmagundi Club in New York City, as well as in various national shows throughout the country.

Tony van Hasselt, a Dutch native, started in commercial design and art-related fields before studying under Frank Reilly in New York. As organizer of *Painting Holidays* workshops, he also worked with its faculty of well-known painters. He was elected to the American Watercolor Society in 1972. His work has been featured in publications such as *Southwest Art* and *American Artist*, as well as in William Condit's *Transparent Watercolor* and Valfred Thelin's *Watercolor, Let the Medium Do It*. He has authored two previous instruction books as well as articles for regional publications and *The Artist's Magazine*.

The Watercolor Fix-It Book. Copyright © 1992 by Tony van Hasselt and Judi Wagner. Printed and bound in Singapore. United States of America. All rights reserved. No part of this book may be reproduced in any form or by any electronic or mechanical means including information storage and retrieval systems without permission in writing from the publisher, except by a reviewer, who may quote brief passages in a review. Published by North Light Books, an imprint of F&W Publications, Inc., 1507 Dana Avenue, Cincinnati, Ohio 45207; 1(800)289-0963.

96 95 94 93 92 5 4 3 2 1

Please Note: Regarding the warning against reproduction of any kind, photocopying *is permissible*, for those pages needed to complete the assignments requested by the authors, as well as page 130, the visual checklist.

Library of Congress Cataloging in Publication Data

Wagner, Judi
 The watercolor fix-it book / Judi Wagner and Tony van Hasselt. — 1st ed.
 p. cm.
 Includes index.
 ISBN 0-89134-431-4
 1. Watercolor painting — Technique. I. van Hasselt, Tony.
II. Title.
ND2420.W33 1992
751.42'2 — dc20 92-15383
 CIP

Edited by *Rachel Wolf*
Designed by *Mark Eberhard*

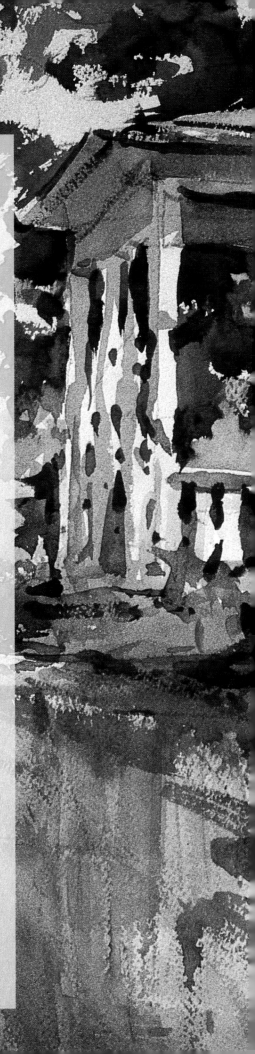

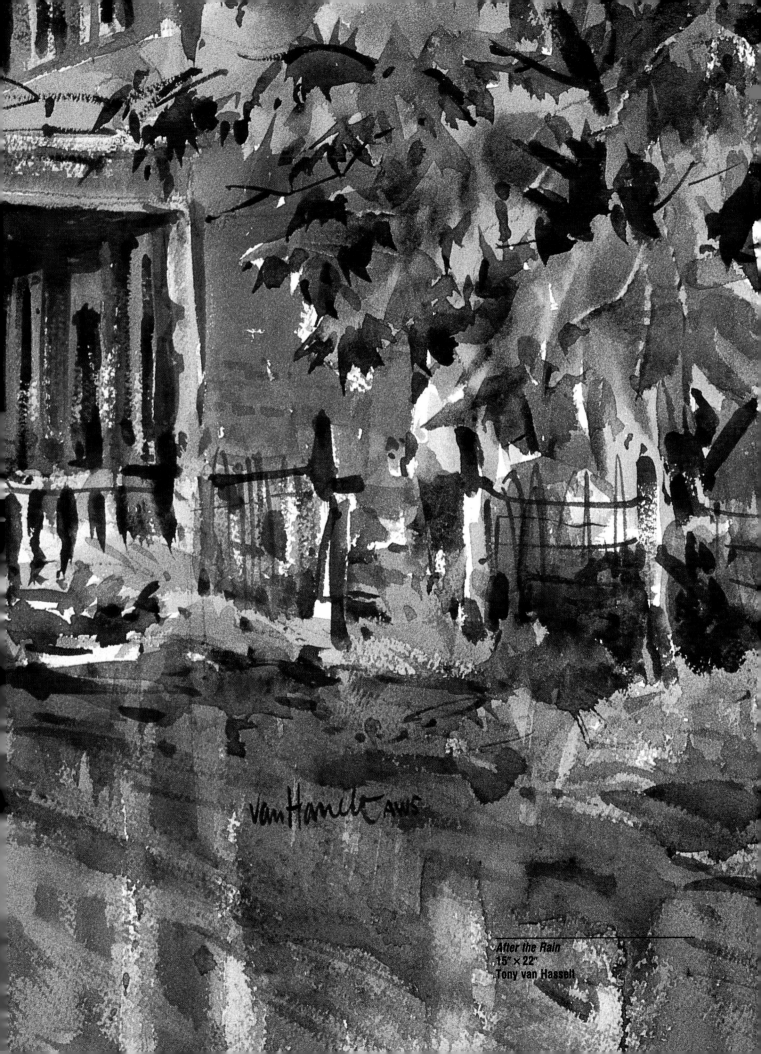

After the Rain
15" × 22"
Tony van Hasselt

Dedicated to those who share our love of watercolor.

Before We Start . . .

This is the place to thank our students who, with their continued prodding, made us sit down to write this visual epic; our collectors who will find "their" paintings in this book; our friends who allowed us to reproduce their work here; and our patient editors, David Lewis, Greg Albert and Rachel Wolf, who continued to believe. To Konrad Wagner, Chris van Hasselt and Ralph Cross for introducing us to the "Computer Age," and to Karen Tonjes for reader reactions. A special thanks to Corinne McIntyre who finalized our visual symbol designs; to Tom Miller for invaluable photographic advice; to Tom, Polly Gott and Jerry McGlish for being good sports. And of course, we couldn't have done this without Toulouse, our faithful Jack Russell terrier, who, with his insistence on a daily walk, kept our lives in balance. These walks inspired some of the better ideas in this book. It was also to him we reluctantly bestowed the title of "Preliminary Editor" after he shredded those watercolors within his reach. Judges everywhere!

Everyone's a critic!

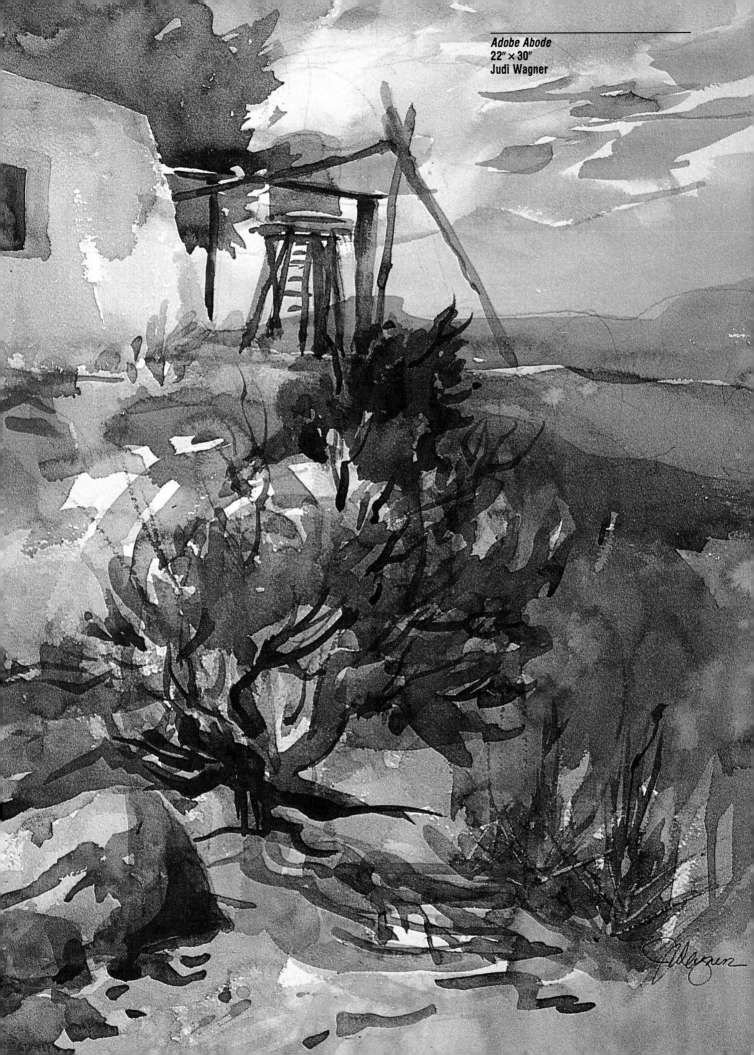

Adobe Abode
22" × 30"
Judi Wagner

Contents

Introduction

Let's face it, artists are visually oriented. When you can *see* how to do something, you learn faster than from simply reading about it. We have, therefore, designed this book with the idea of *showing* you how to fix and improve watercolors, while trying to keep the verbal explanations clear and concise. Hopefully, you will find our efforts educationally stimulating and visually exciting.

As active landscape painters, we find that going through a stack of our past endeavors can be both exhilarating and humbling at the same time. One long forgotten gem brings back memories of a wonderful day at some ideal painting spot, while the next effort just can't be shown to anyone and we wonder where our brains were at the time we painted it. And then there is the ''in between'': The work we look at and know *something* is good about it, but it just doesn't *quite* come off. ''What *will* make this work?'' we ask. ''What *will* make this a better painting?''

In this book, we plan to share with you how we analyze, correct, and improve those works, which for some reason or other didn't ''make'' it, and learn why we lost the enthusiasm to complete them.

Along the way, we'll cover solid advice on the ingredients of successful picture making, so there will be fewer watercolors to fix in the future. Of course, the best way to learn is by *doing*. Therefore, we have planned several exciting exercises to get you immediately involved in the action. Our ultimate aim is not only to improve your existing work, but also to make you aware of potential problems before they become actual problems. Our objective is to decrease the number of works that end up in the pile labeled ''Someday I'll have to fix this one.'' We hope you will enjoy our visually-oriented efforts to do just that.

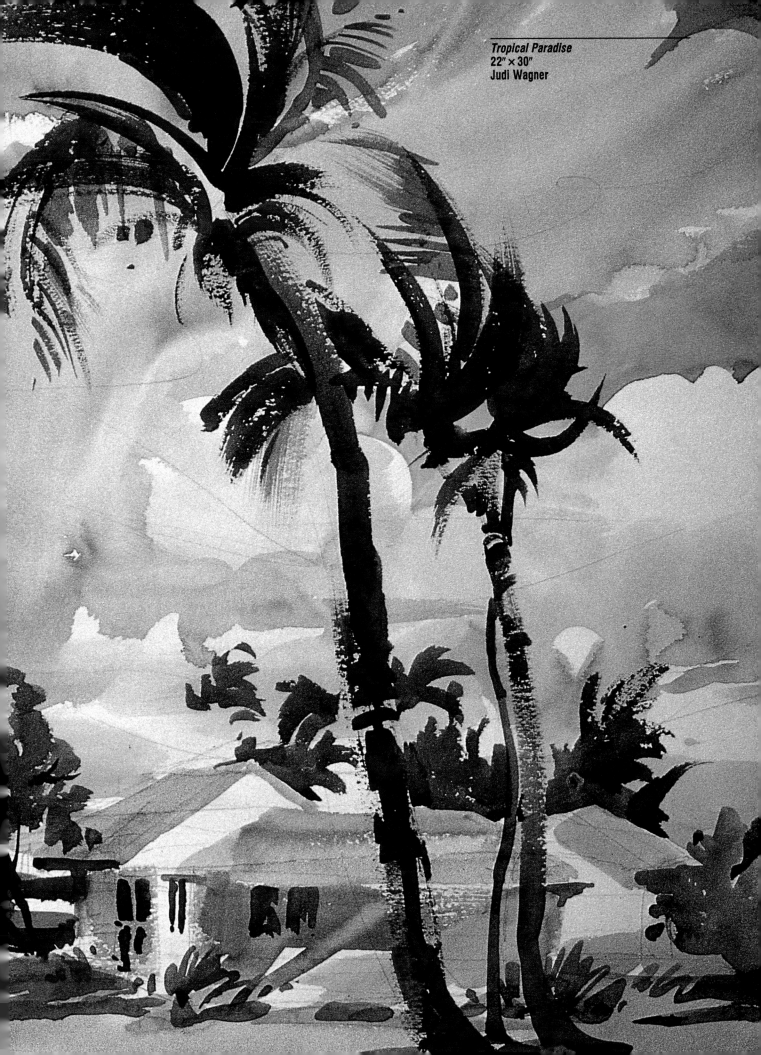

Tropical Paradise
22" × 30"
Judi Wagner

Section One

The Eight Building Blocks of Picture Making

If you have ever looked at a painting and wondered "What is *wrong* with this?" you are not alone. Taking a critical look at unfinished work requires a discerning and educated eye. You need to know *how* to look at the work and by which standard to judge it. You need to know *what* is wrong with the painting before even thinking about adding or fixing anything.

Over the years of looking at our own and student work, we have come to the conclusion that most painting problems fall into eight major categories. If the painting principles of these categories are not observed, our work suffers. Accordingly, we have named them "The Eight Building Blocks of Picture Making." Since artists are visually oriented, we have designed a self-explanatory symbol for each building block and a checklist comprised of all eight. At a glance, this checklist will pinpoint problems in your existing work and remind you to use these building blocks in your future watercolor endeavors.

In the following chapters we will discuss these visual reminders, explain what they mean, and show examples of how they apply. We'll even show where *we* goofed and forgot about these fundamentals. Even though you may be thoroughly familiar with the building blocks of picture making, let's review them once more and get you acquainted with each visual symbol at the same time.

The Homestead
15″ × 22″
Tony van Hasselt

1

General Fix-It Supplies and Information

You will need a few special supplies to correct your watercolors and to do the assignments we have planned for you. These items and their function will be explained in detail as we go along.

In addition, you may wish to make photocopies of the following assignments: One copy of page 20; four copies of the line drawing on page 23; four copies of the line drawings on page 31; two copies of page 43; and several copies of our visual checklist on page 130.

The supplies you'll need are:

- At least one sheet of 9″ × 12″ workable or wet-media acetate.

- A 9″ × 12″ pad of tracing paper.

Cedar Key Vignette
10″ × 30″
Judi Wagner

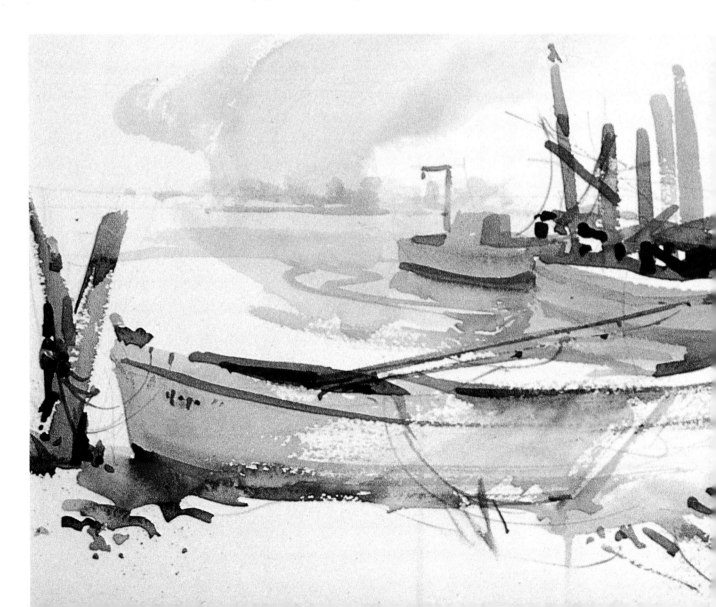

- Any kind of white paper.
- White tissues.
- A no. 8 or no. 10 round brush.
- A small bristle brush.
- Some cellulose sponges.
- Masking materials such as coated paper stock and pressure sensitive adhesive labels or postcards that are used shiny side up.
- Single-edged razor blades.
- Two *L*-shaped mats.
- Paper towels.
- Black and gray felt-tip markers.

The Acetate

We have found a technique to make corrections or additions to a watercolor painting that is better than working directly on the painting and hoping that some lucky accident will happen. By first painting on an acetate overlay placed on the painting, you see the visual effect of an addition before altering your painting. With this technique, you can try anything—and if it doesn't work, wipe it off and try again because you have not ruined a promising, but unfinished, piece of work.

The thin sheets of clear acetate we use are specially treated to accept watercolor paints. This type of acetate is called paintable, workable or wet-media acetate. If your art supply store does not stock it, try a store that carries drafting supplies or place a special order. The catalogs of all major art supply manufacturers list workable acetate.

Should you be unable to locate the workable acetate, you can use regular acetate and add soap to the paint. Simply mix the paint and stroke the paint-filled brush over a cake of soap before applying the paint to the acetate surface. If you do not do this, the

The goal of this book is to help you improve your existing, as well as your future, watercolor painting.

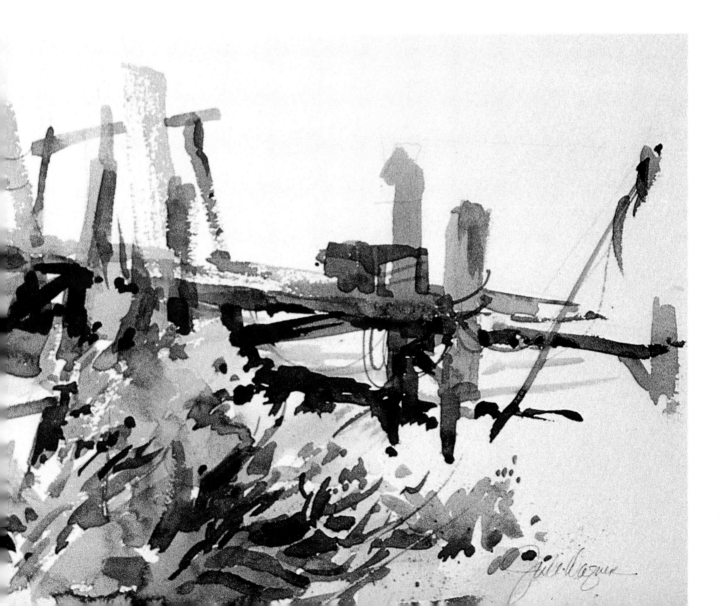

paint will bead up like water on a freshly waxed car. With some practice, regular acetate and soap will work fine. We simply prefer the prepared surface of the wet-media acetate because it is easier to work with.

Throughout this book, we will demonstrate the use of wet-media acetate. Our aim is to get you to work with it at the same time, so we urge you to obtain at least one small sheet of acetate to get full benefit from the exercises.

The Acetate in Action

The demonstration below is based on the painting reproduced in the beginning of this chapter. It will serve as a good example of how we use the acetate overlay to fix paintings throughout the book. The house is well drawn and has good color, but does not show the effect that planes turn corners. It looks flat, as if done on an overcast day, and the work as a whole lacks strength.

To solve these problems, we can superimpose an interesting shadow pattern over the building and turn the overcast day into a sunny one. We do this by placing a sheet of acetate over the painting and, with a no. 8 or no. 10 round brush, painting the shadow pattern right on the acetate. At bottom right is a combination of the actual painting and the acetate overlay. The shadow shape, shown by itself, pulls the whole painting together and adds a three-dimensional quality to the building.

With the help of the acetate, you can see how the work will be affected. If you don't like the changes, simply wipe them off and start over. When you're satisfied with the results, it is time to put the acetate aside and paint those changes right onto the actual painting.

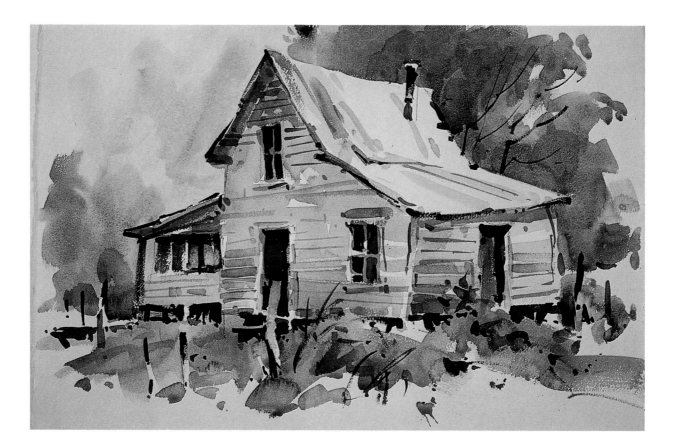

By painting the shadow shape right on the acetate, you can see the effect it will have on the painting. Here we moved the acetate off the painting to show the shadow shape by itself.

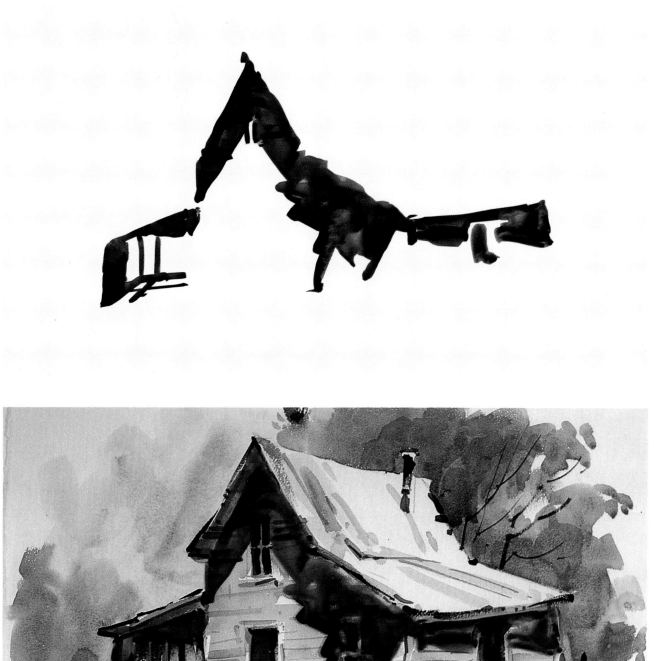

Using the Acetate

Although you can use either side of the acetate, you'll find that painting on it is a bit different from working on paper. You'll need to work flat to avoid the paint's dripping or running away. In addition, you will have to use a thicker consistency of watercolor paints. Thin, delicate washes will not show up as well as the darker value ranges. We avoid using white paint on the acetate. Instead, in Chapter Twelve we'll show you another way to introduce whites and light values.

This acetate may be used over and over again. To remove paint, simply wipe it off with a dampened paper towel. You may need to clean the acetate more thoroughly with a second towel. The only color that shouldn't be used on acetate is phthalocyanine green or any color that has phthalocyanine in it, because it may permanently stain the acetate.

To get the feel of working on this slick surface, you may wish to simply copy our shadow shape. Place the acetate over the reproduction on the bottom right and go to it.

How about another try? This time, create your own shadow pattern by moving the direction of the sun to the left instead. How will that affect those shadow patterns? Try and see. What would happen if the sun was *behind* the building? Would the resulting shadow shape add that three-dimensional quality or again flatten the house out?

As you can see, using the acetate gives you a preview of what those additions and corrections will do to the painting. You no longer have to dab and hope something lucky will happen. You have the chance to *improve* the work instead of taking the chance of ruining it.

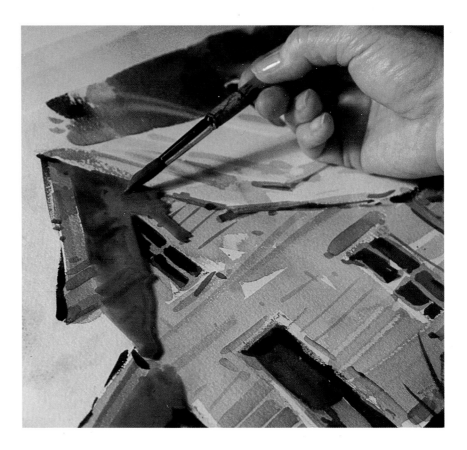

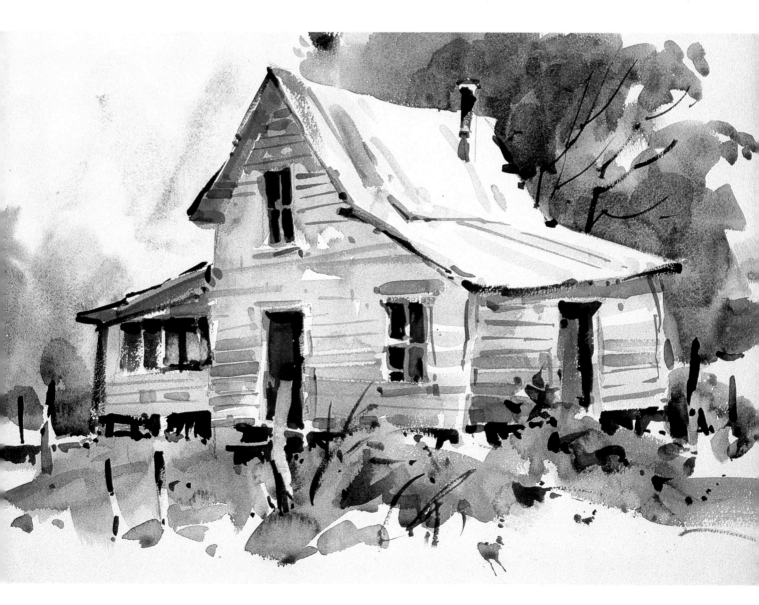

Monhegan Motif
22" × 30"
Judi Wagner

2 Value
The Most Important Building Block

In a nutshell, keep values few and simple. Our symbol suggests using three. A light value, a medium value and a darker value. In addition, there is the white of the paper and the accent of very dark colors, suggested by the symbol's black outline.

The bulk of a painting usually consists of these three major values. The white and dark are *accents*, which add punch. Obviously there are many more values in the actual subjects but close values need to be grouped together so they will not overwhelm the viewer. Let's keep it simple.

Oregon Remembered is a good example of what is meant by "grouping." As you can see, there are several different values in the foam spray as well as in the rocks. However, looking at this scene through half-closed eyes, you only see a few major value patterns. The many closely related values all become one value within a group.

As long as the three value patterns can be clearly identified, our work will hold together. This value scale could be compared to a musical scale of three notes. When selecting a subject, we often "hum" these three notes to

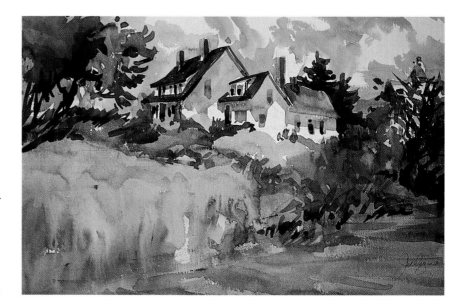

Blustery Day
22″ × 30″
Judi Wagner

The three major values hold this painting together, while the accents of white and dark focus the eye on the center of interest.

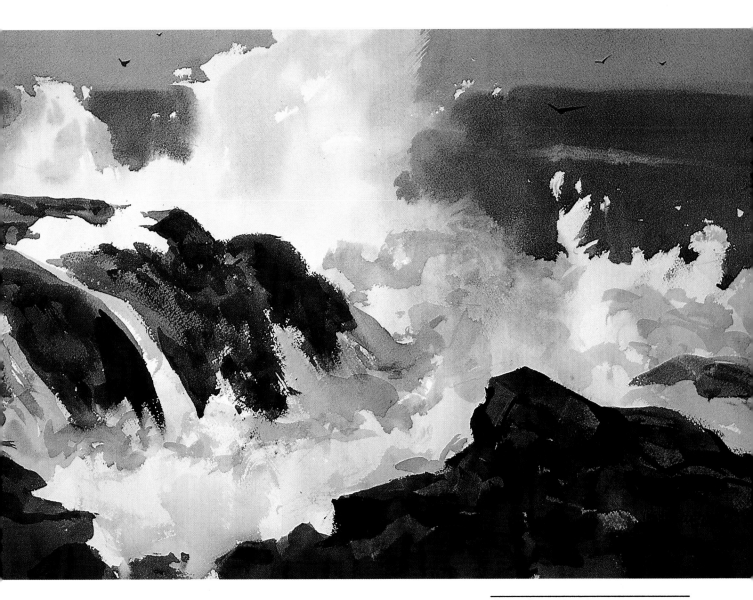

Oregon Remembered
15" × 22"
Tony van Hasselt

Looking at a scene through half-closed eyes causes closely related values to form themselves into major value groups. This may be observed by squinting at the different values in the foam spray as well as in the rocks.

see if their comparative values can indeed be found in the subject. We even point to them in the scene and, of course, all this is done while we are squinting. No wonder folks look askance at us artists.

Squinting is a great tool. Looking through half-closed eyes eliminates all those details we feel are so important. It simplifies complex scenes. We *cannot* over emphasize the importance of squinting when selecting subject matter, while in the act of painting, and when judging a work that needs help.

Stream Reflections
22″ × 30″
Judi Wagner

In the representational landscape, sky is light *giver*, earth is light *receiver*.

Woodstock Summer
15″ × 22″
Tony van Hasselt

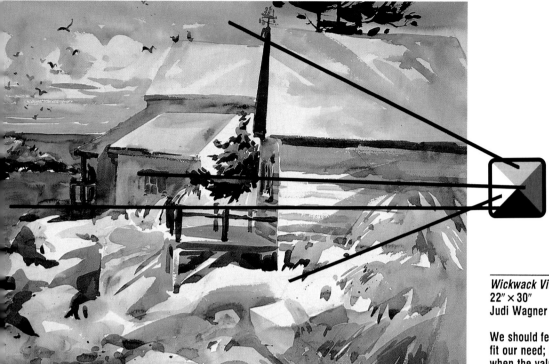

Wickwack View
22″ × 30″
Judi Wagner

We should feel free to manipulate values to fit our need; referring to basic truths *only* when the value patterns create confusion.

Earth Values Versus Sky Values

There is a strong earth-sky value relationship to be considered by the *representational* landscape painter. Basically, the sky is the light *giver*, the source of light. Earth is the light *receiver*, reflecting the light. Therefore, it stands to reason that earth values are generally darker than sky values. Included in earth values are all natural phenomena belonging to the earth or nature: objects such as rocks, meadows and trees. Of course, there are always exceptions. For instance, look at the water in *Stream Reflections*, upper left, or the roof in *Woodstock Summer*, lower left. Both are as light as the sky, pointing out that water is basically a surface that can reflect sky values and that anything created by people can be as light as, or *lighter* than, the sky.

Know that this earth-sky relationship exists, but as *Wickwack View*, above, suggests, apply it or ignore it as the situation requires.

Values can be manipulated to fit *our* needs. While taking a critical look at a painting that needs to be fixed, you should at least consider whether the work needs these solid earth values. Ask yourself, "I know the earth should be darker in this spot, but is it effective as it is or should I indeed darken it?"

Comparing Values

The eye is a wonderful tool and knowing how it works will help you use it even better. Very basically, in the "in focus" area of the eye is a grouping of optic nerves that distinguish color. A different grouping of optic nerves is located in the peripheral vision area of the eye. They distinguish values — how light or dark something is. In practical application, this means that if you need to know the *color* of an object, look at it. If you need to know the *value* of something, look at a neighboring area and out of the corner of your eye, become aware of the relative lightness or darkness of the object.

Another way to judge a value is to compare one isolated area to another. For a demonstration, use a paper punch to remove the two circles in the value comparison strip on the front, inside flap of this book. Place the strip over *Maine Morning,* below. Note the differences in value between the two circles. This little gadget is a handy tool when you need to compare values, so cut it out and start using it.

Maine Morning
22″ × 30″
Judi Wagner

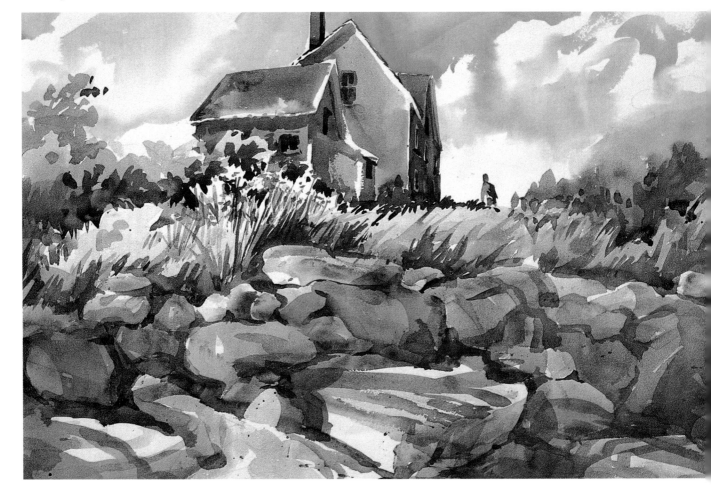

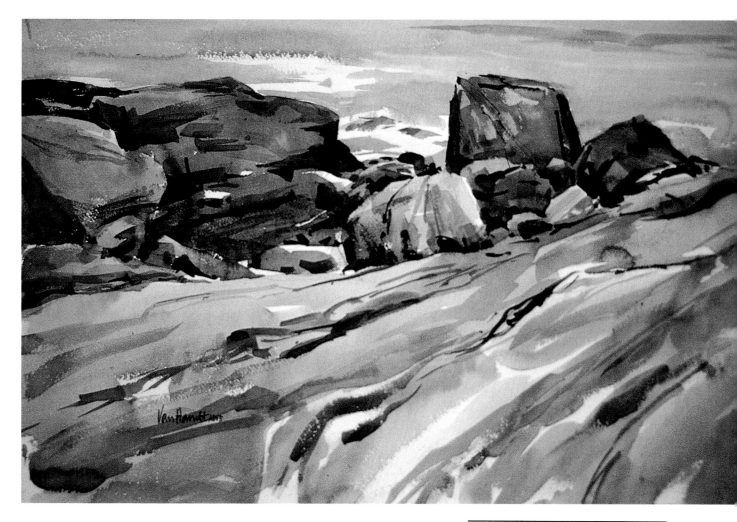

Ocean Point
15" × 22"
Tony van Hasselt

A Value Exercise

The problem with this otherwise creditable painting is that the light and dark values exist, but the mid-value is missing. Notice that although the temperature and color of the water and the foreground are different, the *values* are the same. Here is where the problem lies. Interestingly, there are two ways this problem can be solved. First, a warm value can be glazed over the foreground rocks, or if we don't like that, a dark cool wash can be applied over the water area instead. Place the acetate over this painting and try both options to see which you like best.

3 Alternation
The Building Block That Clarifies

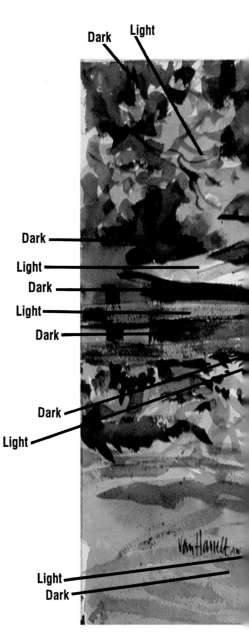

Basically a light value should be placed against a dark one and a dark value against a light. We have visually simplified this concept in our symbol with the checkerboard design of white next to black.

Of course, when you're using a *full* value range, this checkerboard idea simply means that an area should be lighter or darker in value than a neighboring one. How much lighter or darker depends on the broad value plan this area belongs in — where the area is located and how much attention it should attract. For instance, the strongest value differences are usually reserved for the center of interest. As you near the edge of the paper, it is wise to decrease value contrasts between adjacent areas.

When judging a painting, keep asking yourself, "Am I using the alternation concept fully to interpret this scene? Am I playing light against dark and dark against light?"

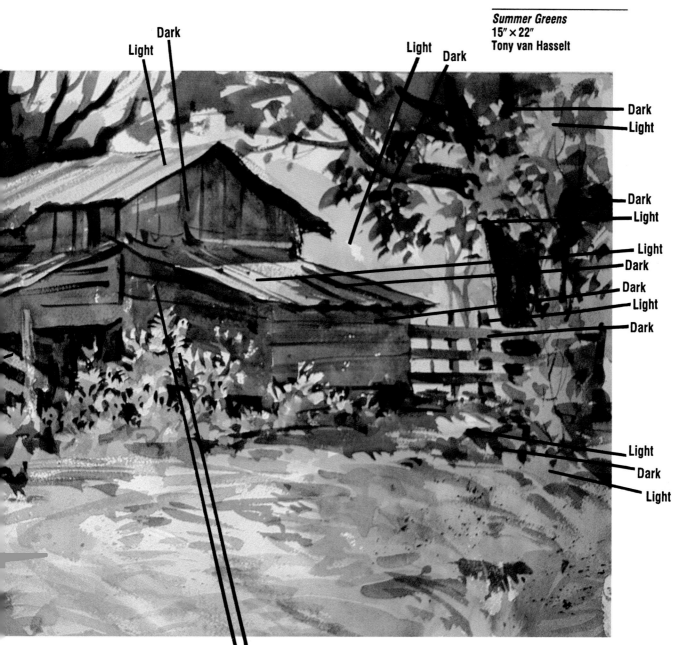

Dark

Light

Light

Dark

Dark

Light

Dark

Light

Light

Dark

Dark

Light

Dark

Light

Dark

Light

Light

Dark

Summer Greens
15″ × 22″
Tony van Hasselt

Alternation: The Building Block That Clarifies

For a further clarification of the alternation concept, we simplified *Summer Greens* into a one value pattern of light and dark. As you see, this very limited black-and-white approach can still make a clear statement. You don't actually *need* all those values and colors to describe the subject accurately.

When selecting a subject, we automatically look for that light and dark alternation pattern. A sunny day is perfect, since it gives clear shadow patterns. In essence, the black shapes represent all the shadow areas and dark local colors, while the white ones represent all the sunny or light patches. If our subject does not have good value alternations, we have a choice: select a different subject or *impose* alternation onto that subject. Of course, the only way to start seeing such strong light and dark patterns on a sunny day, is to . . . you guessed it, *squint*.

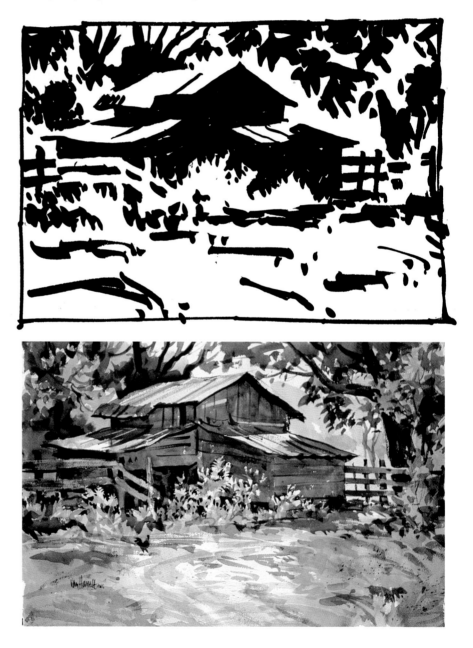

How the Checkerboard Concept Works

1. THE CHECKERBOARD

The checkerboard concept clearly shows that a light always needs to be next to a dark or the whole checkerboard will become unclear and unreadable.

2. THE ARTISTIC CHECKERBOARD

Although the previous checks were perfectly balanced, they were all of equal size and that is boring. In the artistic checkerboard there can be large, mid-sized and small squares. You can use rectangles instead of squares — long skinny ones and big fat ones. And don't forget the white "squares." They'll get more interesting as well. Just keep in mind that the "board" still needs to be balanced.

3. THE CHECKERBOARD APPLIED

One problem with the checkerboard terminology is that it makes one think of — and tend to paint — squares or rectangles. But don't limit yourself. You can paint any shape desired, as this alternation example clearly explains. Take time to study this sketch closely. It clearly places light shapes against dark ones and vice versa in a true checkerboard manner.

20

Manipulation of Values

Sometimes a painting just can't be fixed and needs restructuring before it can be repainted. In such a case, alternation can be used. We look at what the subject consists of and try different alternation schemes as shown on the left. Remember that *we* are in charge and *we* can be the lighting directors of this production, so we move the light source and props around in different ways to see how to best express what we wish to say.

In the top two examples for instance, there is an equal interest in the interrelationship of the house and the tree, while in the lower two, these two "actors on the stage" are still there, but the tree seems to draw more attention than the house. Notice also

our freedom with the props: the freedom to move things around, to add a distant mountain, or a chimney and its shadow to tell you where the ridge of the roof is located.

By this time you may ask, "How does this alternation concept help me to finish *my* work?" You should use it as a reminder to see if all the important areas in the painting are clearly stated. We often see paintings that have figures added to the scene. These figures may be nicely handled, but if their value is too similar to the surrounding ones, they can't be appreciated. They can't be *seen*. The alternation concept will prevent you from falling into such a trap *initially* and will help you recognize the problem when evaluating work.

Vermont Farm
22″ × 30″
Jack Jones

The black-and-white value alternation principle is ideal to put into practice on sunny, close-up subjects. But in a grand panorama such as this one, we prefer to use a full value sketch, since the need to be clear with our value patterns still exists.

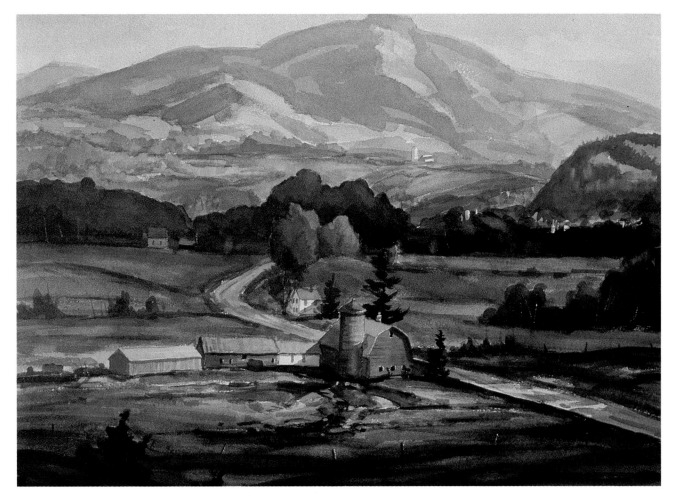

Alternation Exercises

On page 20, you saw some stark black-and-white renditions of a subject. Of course, when actually painting, we work with three additional values that *replace* most of the black areas and *adjust* most of the stark whites.

To approximate this effect, make a photocopy of page 20, or place your acetate over the art on that page. Use a gray felt-tip pen on the copy or use a mid-value gray paint on the acetate and apply it over all the white areas except those that you wish to be the center of attention. Notice for instance how your eyes are drawn to the whites in the example below.

Try your own hand at manipulating values. Make four photocopies of the line drawing on the top right, or place acetate or tracing paper over it. Use black watercolor paint on the acetate; use India ink or black felt-tip pen on the photocopies or tracing paper. Decide on the light direction and then paint all the shadow areas on the building. This then dictates whether the adjacent areas will be white or black. Don't forget the cast shadows from the frontal addition and the barn itself.

Please don't get fancy by using a variety of values. Just stick to black. Next, try the light coming from the other side and see how this will affect the alternation scheme. Try to do four different schemes and feel free to add cast shadows from trees not seen in the picture. Be inventive. You'll be amazed at some of the fancy footwork you'll have to do to keep the checkerboard going and not to lose identifying shapes.

The last exercise, bottom right, is even more exciting. Note how all the values are quite pale, much like those early watercolors we painted when we were afraid of ruining a "masterpiece." There is nothing wrong with such work as long as we recognize that it is an early *stage* of the painting. Place your acetate over this exercise and select one of the checkerboard examples you've done. Assume that all the whites in your sketch represent the areas already colored in. Your job is to add darker colors, strengthening values according to the checkerboard guide you selected.

22

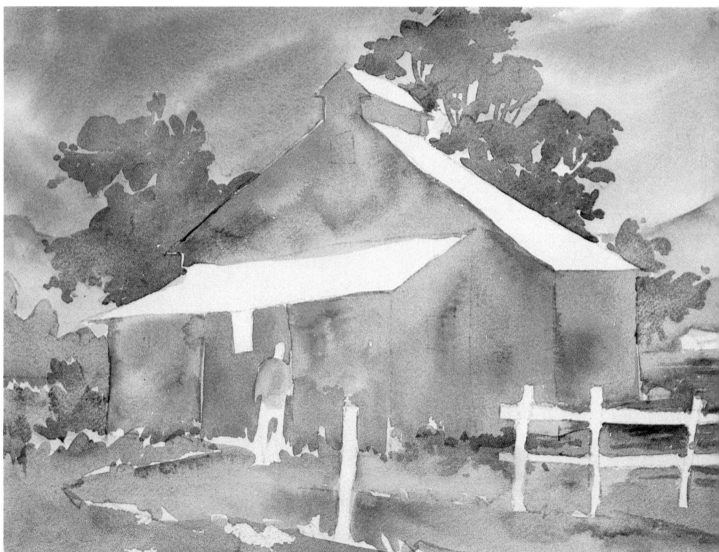

Alternation: The Building Block That Clarifies

4 Shape
The Painter's Building Block

As you have seen in the last few pages, it is very important to place a light value against a dark one. In addition, that light or dark shape must express what it *is*. For instance, the unique outline of the *S* in the above symbol is a telltale shape. It is readable in the black area as well as in the white one. It is a shape that interlocks whites with darks, positive with negative, as you will see in this chapter.

Painting is very different from drawing. In drawing, we deal with lines. As the drawing on the previous page shows, lines are actually *demarcations* separating one area from another, as we remember from our coloring books. Such demarcation lines are seldom found in nature. There, we see values and colors *within* shapes. It is the painter's job to interpret those shapes so they can be recognized and un-derstood. "That's the way it was" is not the answer because we can't always be there to explain. The work has to explain *itself*. We must place ourselves in the shoes of the casual observer and ask, "Do I understand there is a house hidden behind that foliage? Do I recognize a boat shape behind those pilings?" Then, as the painter, ask, "Which are the best telltale shapes I can use to display that house or boat?"

Let's take a closer look at what shapes are all about.

You cannot judge a shape you cannot see.
Edgar A. Whitney

Shackford Patterns
15″ × 22″
Judi Wagner

To us, this is what watercolor is all about. A luscious intermingling of colors within clear and simple shapes linked together with that precious white of the paper.

Drawing Versus Painting

A painter *draws* where things *go* and *paints* what things *are*. It is important to know how to draw, but as painters we must concern ourselves more about shapes. While drawing, we work with outlines to describe a subject, ignoring the light source. While painting, the subject comes into existence *because* of the light source. Light creates shadow shapes; it creates a positive and negative interaction of lights and darks. As painters, we must concentrate on what shapes we put down *and how these shapes in turn affect the "leftover" white or light shapes.*

Painters are shape-makers. It is our tool in trade. Once we have decided on the right shapes and we have painted those shapes in the right color and value, we are virtually finished. All that needs to be added is surface texturing and finishing details to bring our painting to completion. It sounds simple, yet we get so confused with those surface details. We feel they are so important that we need to render them *first* instead of realizing that they come *last*. Surface details are the icing on a cake. For instance, it would take very little surface finishing to transform the color diagram below into a painting.

Looking at Shapes

Observing a painting, we are enthralled with its color, texture and brushwork. Only when these ingredients are taken away do we become aware of the importance and beauty of the *underlying* shapes. When you limit yourself to just black and white, you are forced to concentrate on the shapes.

Take a look at black-and-white advertising pages for outstanding shape examples. Shapes to avoid are those that measure the same horizontally and vertically: the square, the circle and the triangle. Believe it or not, we encounter

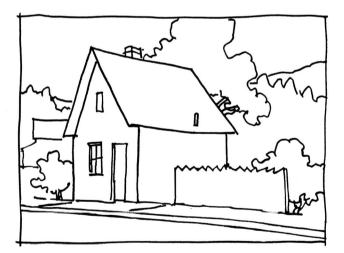

DRAWING

As representational artists, we need to know how to draw. Everything else is based on it. We work with line to describe a subject and indicate where things will be located within a picture such as this. We know that in reality there are no outlines around a house or tree.

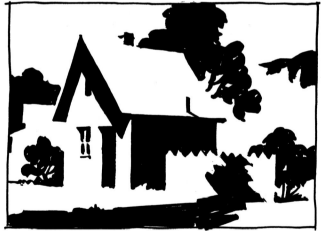

SHAPE-MAKING

Observing this same subject as painters, we forget about lines and squint to see how light affects the scene. We look for interesting shapes of light and dark. We decide how to make boring shapes more interesting. We find ways to balance the light and dark shapes.

these boring shapes all the time. The square in the two top right examples for instance, and the circles in the bushes and trees. Even the triangle can be found in our painting attempts. Besides, any one of the three can appear in a negative form as well, so watch out for those boring shapes. They are sneaky.

The shape to aim for is the one that has different width and height measures—a shape that interlocks with other shapes the same way pieces of a jigsaw puzzle fit together. As an example, take a look at the shapes lifted from the diagram below and compare them with the square, circle and triangular shapes.

As shape-makers we must entertain the viewer with exciting shapes that tell the story. We must present objects from their best, identifying silhouette angle. We must be vigilant that one silhouette does not obliterate the storytelling capacity of another. Finally, we should try and tell more than one thing with each shape, as the example on the next page points out.

When a boring shape is selected, it makes no difference how accomplished the rendering of it is. It remains a bad shape.

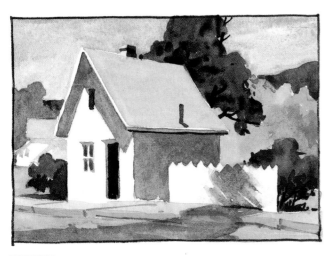

PAINTING

Once we have decided on which shapes to use and how to achieve balance, all that remains to be done is to place the right color and value within each shape. Although this is a simplified visual explanation of the painting process, it does point out the importance of the shape-making process.

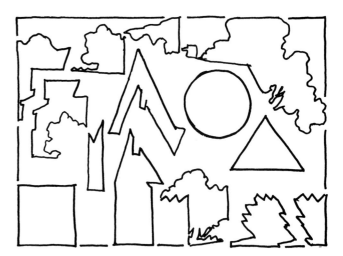

Compare the outlines of positive and negative shapes found in the diagram to the *left* with the non-interlocking outlines of the square, triangle and circle.

BORING SHAPES

The circle is definitely one of the outlines, but not the identifying silhouette, of a pear. Even Rembrandt would have problems depicting this as a pear. The triangle can be found in the gable of a house and the square in the open barn door. If you have to work from this direct angle, let some other shape appear in front of these boring ones to break up their outlines.

BETTER SHAPES

Even a beginner will be able to depict a pear displayed with a telltale outline, such as shown here. The gable shape and barn door, when viewed from an angle, become more interesting shapes because their width and height dimensions are no longer the same. Note that these shapes just sit on the surface of the paper. They do not relate and interlock with it.

INTERLOCKING SHAPES

In this column, shapes interrelate with the white paper much like the pieces of a jigsaw puzzle lock into each other. The highlight on the pear blends in with the background and the shadow anchors it to a surface. Even the stem adds to the interlock. Shadows transform our gable into an exciting shape, and partially closing the barn door makes the square a more exciting shape.

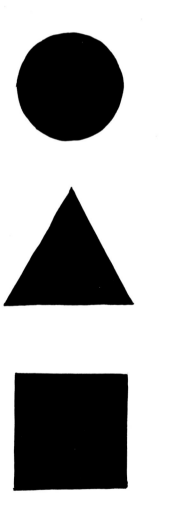

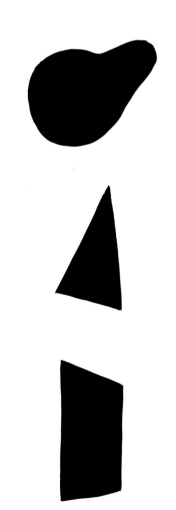

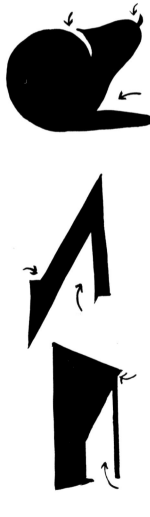

Martinique Maison
15" × 22"
Tony van Hasselt

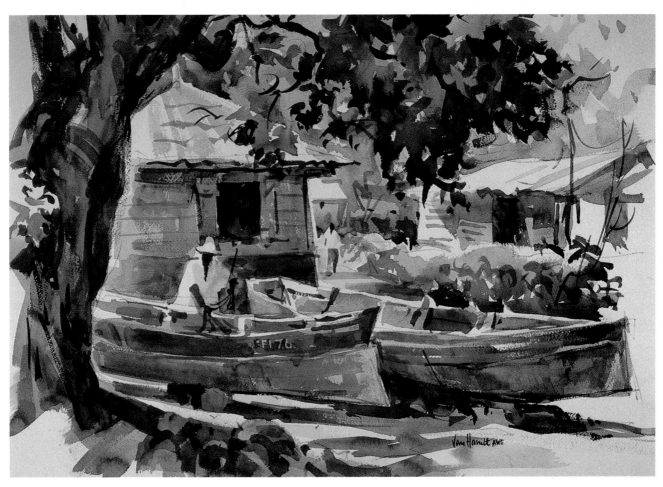

Overlapping Shapes Correctly

When several objects are combined in a painting, we have to make sure that each is displayed at its best. In *Martinique Maison*, above, for instance, there are the silhouettes of the tree, foliage, a person, houses and boats, all overlapping in such a manner that one object does not confuse the outline of another. Avoid overlaps at corners since these seem to be the most telltale part of an outline.

Don't just paint *one* shape. Try to say more than one thing with each shape.

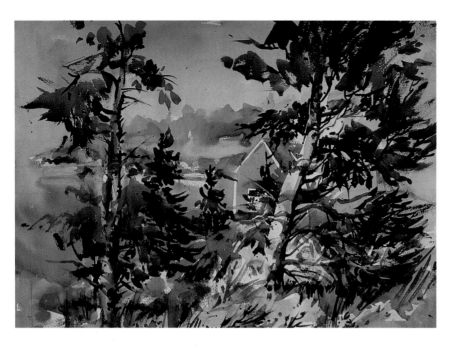

Cove through the Trees
22″ × 30″
Judi Wagner

Where one object's outline overlaps others is crucially important. Avoid overlapping outlines at corners since these are the most telltale part of a silhouette. This painting illustrates that you can almost obliterate the outline of a house, but as long as a few corners peek through, that house will remain a readable structure.

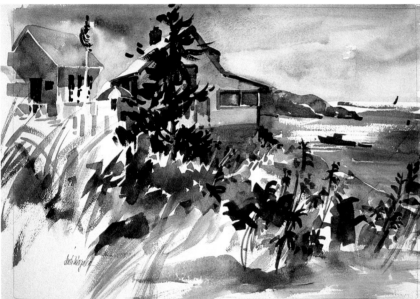

Monhegan Afternoon
22″ × 30″
Judi Wagner

Although the building shape in this painting is quite clear, the tree comes dangerously close to obliterating the outline of the roof at its peak identification point.

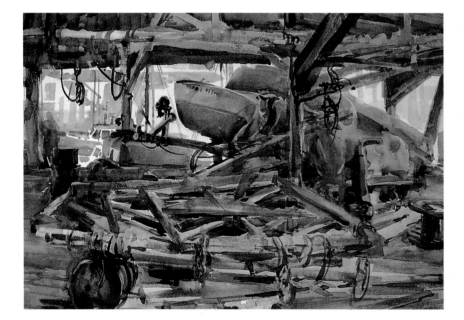

Rainy Day Subject
22″ × 30″
Judi Wagner

In this boat shed painting, the stern of the boat is a clearly displayed outline we can easily discern, while the area to the right does not feature a clear shape. Our eye longs to either see a better boat outline or another understandable silhouette in front of the boat.

30

Shape Exercises

Make four photocopies of the above drawings. With India ink, black paint or a felt-tip pen, add trees and foliage in front of the house to see just how much of it can be hidden before the viewer loses the idea that a house exists behind all that foliage. Try several ways. To be successful, you will need to show as many corners as possible.

Taking the line drawing of the above boat as a guide, use India ink or a black felt-tip pen to transform it into a successful interlocking shape. Try this a couple of different ways and ask yourself, "What can I do to make the side or stern shapes more interesting?"

Docks and pilings often obliterate beautiful boat silhouettes when the tide level is not favorable. To demonstrate this, place your acetate on *Brunswick Docks*, below, and paint some more pilings on your acetate. Then move the acetate around to place the pilings at spots that overlap the boat outline but do not challenge its telltale silhouette. Note that these pilings create confusion when placed on top of the bow or stern, proving the point that the corners of an outline should be clearly displayed.

Brunswick Docks
15″ × 22″
Tony van Hasselt

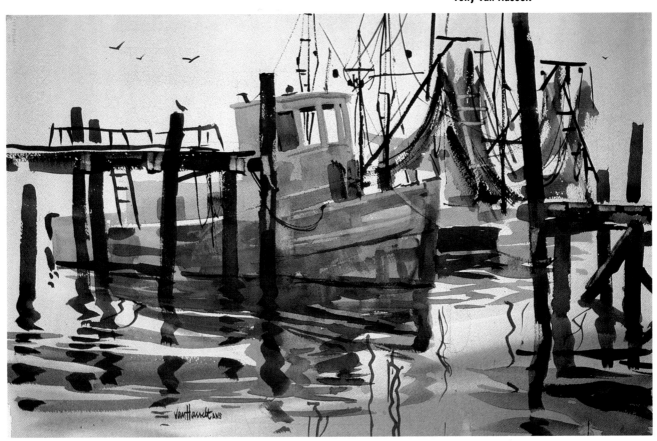

Positive and Negative Shapes

In landscape painting, positive shapes are the ones that can be touched: objects such as houses, trees, fence posts, etc. Negative shapes are those background spaces visible *between* things. Using our symbol as an example, it can be said that the S in black *and* white is positive, while in the background, the black *or* white area is negative. Note that the negative shape of the background *creates* the positive S shape.

During the beginner stage we seem to be cognizant of the positive shapes — the "things" — while virtually oblivious to the value or color of the surrounding space. We seem unaware that the surrounding negative shape *creates* the positive one. Let's look at some close-up examples at the right.

1.

In part of this detail, the actual leaves were painted, while in other places the negative space *around* the leaves was depicted, thereby bringing them into existence.

2.

In this example, we never placed a brush-stroke on the house. It appears to exist because the negative shape of the sky conforms to the house outline.

3.

The chicken and rooster form a good checkerboard alternation. The white hen exists only because the *background* was painted around it. Note the repeat of those shapes in the window.

4.

The church dome came into existence simply because of the shape of the sky. A few identifying shadows and calligraphic marks were added for further clarification.

5.

These palm trees play hide-and-seek against the sky — becoming a positive, painted surface and then disappearing into a white paper existence outlined by the negative sky area.

6.

The flowers were established by the background shape, then additional brushwork delineated the shadow shapes of the blossoms to relay just the essence of this bouquet.

7.

This Mexican market figure becomes a walking checkerboard alternation with the background. Her upper torso was established by painting *around* it when we worked on the background. Only then did her arm and skirt become positive additions.

8.

How can you paint another fence post? By painting everything around it and leaving the untouched paper as the post. Note also the similar treatment of grass and weeds.

9.

The tree behind the house, because of its shape, tells us it *is* behind the house. Similarly, the white porch posts come into existence because of the background. Where the background becomes white, the post becomes a positive mark on the paper.

1

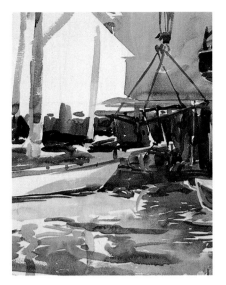

2

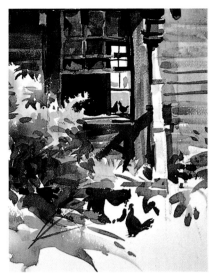

3

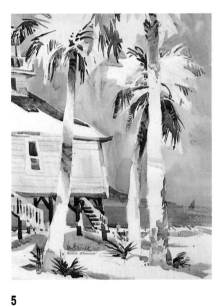

4

5

6

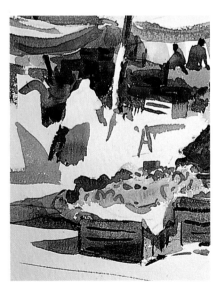

7

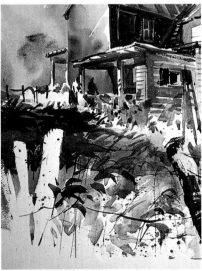

8

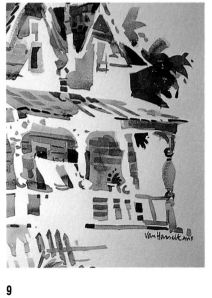

9

Positive/Negative Exercises

Painters working in opaque media can add white paint on top of their other colors. Watercolorists have to think ahead and *save* the white paper. So we have to be *especially* aware of negative shapes. We have to do two things at once when applying paint: save and *shape* the whites. In other words, you must *work* the paint and *watch* the untouched paper at the same time.

To develop the habit of seeing negative shapes, we designed two exercises that should be very helpful if practiced regularly. You will need some unlined paper and a black felt-tip pen. Next, *envision* a short name or word that is to be rendered in a negative manner. *Without* pencil outlines, suggest a minimal amount of background shape, just enough to indicate a corner of a letter. Build

from there. Envision each letter and make it thick, *connected* with the next one like the examples on this page. Note that all the straight letters are slightly angled so they can be easily connected to each other.

Please do not be precise. At the same time, if the word is not readable, the negative shape is not clear. Keep trying, because this exercise really teaches you how to make a shape while at the same time looking at the shape of the untouched paper.

The tree exercise starts with a basic pie shape that points to the trunk. *Envision* this trunk. Drawing it first and filling in the spaces negates the benefits of this exercise. Once a pie shape is down, place a different sized triangle one *imagined* limb space away from it. Keep adding more triangles of different dimensions until the tree emerges from the paper.

You could also use a variety of colors to paint these triangles on a small watercolor block. Start building trees by painting what is seen *behind* them. The results can be surprisingly pleasing.

Falltime Palette
10″ × 12″
Tony van Hasselt

5 Balance

The Building Block That Adds Solidity

Balance is usually referred to as the visual equilibrium of light and dark values, of mid-tones as well as colors. Our symbol balances a triangle on its point. It is a good example of symmetrical balance; both sides are even. It is the least desirable type of balance for the landscape painter. The more exciting way to balance values and colors is asymmetrically.

Most of us possess an innate sense of balance. We are automatic picture straighteners. We *want* to even things up. Knowing when paintings are unbalanced, why do we fall into the trap of producing unbalanced work? It may be because the groundwork was not done prior to painting. When time is spent on doing a preliminary sketch—just concentrating on balance—we'll get it right. When this process is skipped, an inexperienced painter may immediately start rendering the subject without any thought about balance.

In this chapter we will concentrate on *how* to look for balance in the preliminary sketch and what balance is all about.

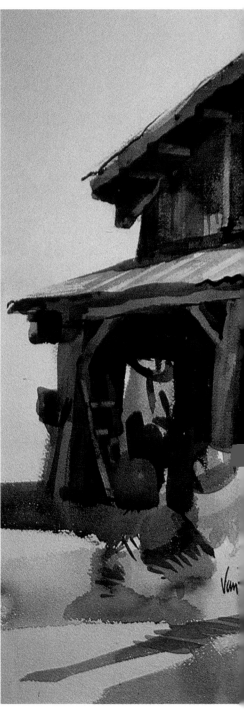

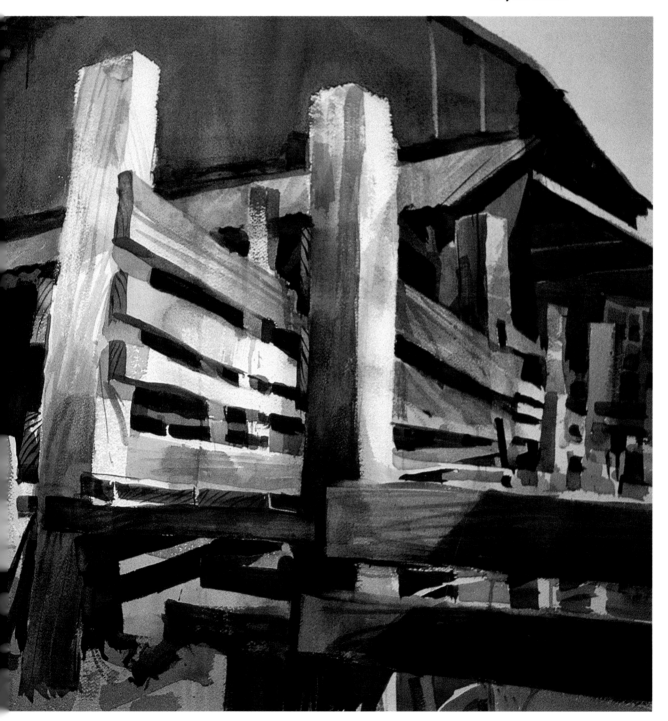

Balance in the Preliminary Sketch

Beginners usually skip the preliminary sketch because of a fear that it will waste too much time. Remember, the only purpose of this sketch is to achieve a balanced distribution of light and dark masses. You are *not* creating a miniature painting. The sketch should not take much time and energy because those are needed for the actual work.

Our preparation consists of a postcard-sized sketch, done with a no. 10 or no. 12 round brush. This tool makes it impossible to render picky details, which are too tempting if a pencil is used. We use just a mid-value gray and with it simply record the shadow patterns and dark local values, those darker values that remain visible while you're observing the subject through half-closed eyes. This is a *pattern sketch* since it consists of patterns of shadow. It is an *abstraction* of the subject as can be seen in the sketches of *Battenkill Barn* and *The Shackford Place*, below.

Looking at this sketch, we judge if the dark shapes are balanced as well as the lights. We may not like the first sketch and do several others before solving the balance problem. With our tool and size limitations, these sketches take only a minute or two, leaving enough energy and excitement to do the actual painting.

The Shackford Place
22″ × 30″
Judi Wagner

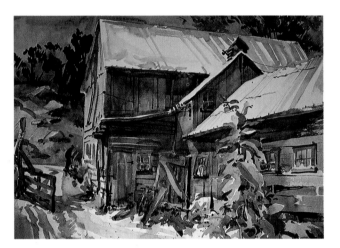

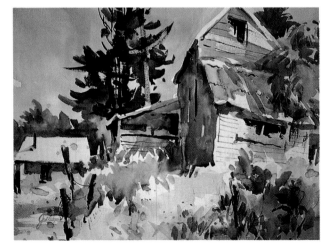

Battenkil Barn
22″ × 30″
Judi Wagner

38

Dancing Mesa
15" × 22"
Tony van Hasselt

In the average landscape, our first concern is to balance the darks. Here, the major dark area is placed right in the middle. It is a safe but unexciting way to achieve balance. A darker area had to be added on the left and balanced on the right, just to get out of that centered trap and save the painting.

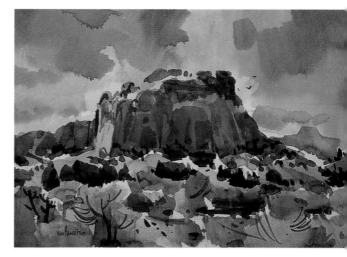

Monhegan Monday
22" × 30"
Judi Wagner

Here is another example of balance. If the artist places a heavy weight of dark on one side of a painting, it requires an equal-sized weight on the other edge to create balance. The result of this technique is that the viewer might be torn as to where to look first. In this case, since the painting has a good center of interest, the eye is directed to it instead of to the darks, and they become a static foil for the scene.

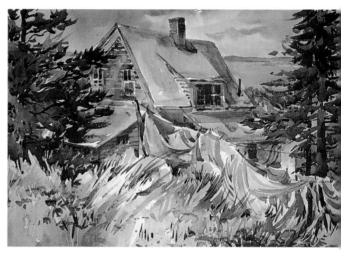

Adobe Abode
22" × 30"
Judi Wagner

Here is a unique aspect of balance. If you place a large dark mass *close* to the center of the painting, it takes only a small amount of dark to balance this mass. This phenomena is often compared to a seesaw; the big child sits close to the center, equalizing the weight of the smaller one at the end of the seesaw.

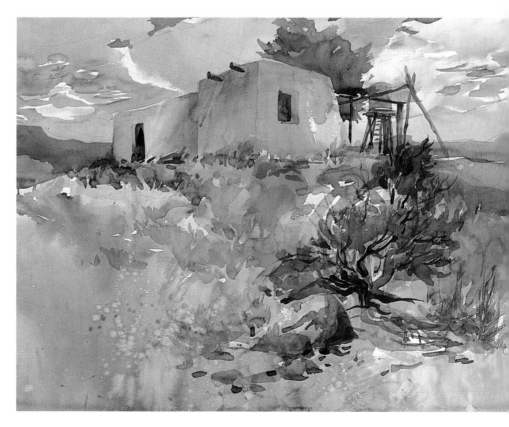

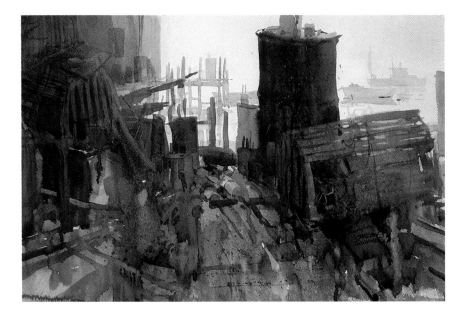

Wharf Silhouettes
14½″ × 20½″
Carlton Plummer, A.W.S.
Collection of the artist

To illustrate two other aspects of balance, we'll use two works by our summer neighbors from Maine. The painting at right clearly shows that a small dark shape can be balanced by a large mid-tone. Although it is not shown here, this same theory applies to color as well. A very colorful spot can be balanced against a larger, more muted area of the same general color.

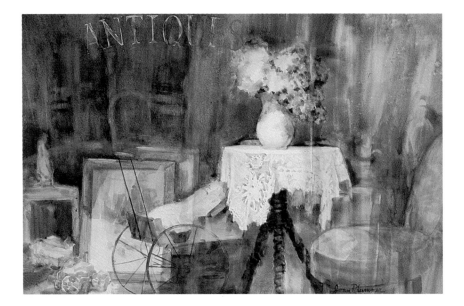

Australian Antiques
20½″ × 28½″
Joan Plummer, N.E.W.S.
Private collection

Balancing the whites is as important as balancing the darks. In the painting on the left, note where the primary white shape is placed and how it is linked to and balanced by the other whites. This work is also a good example of color balance. Note how the blue area above is repeated underneath the table and how the yellow-orange in the lower half of the painting is echoed by the yellow-orange letters and flowers.

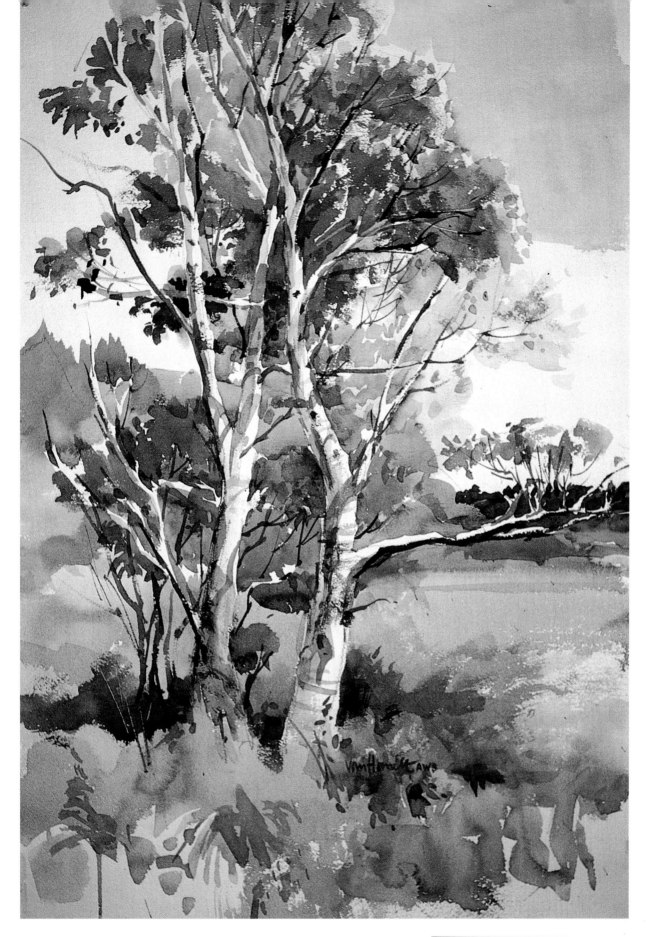

Fall Colors
15" × 22"
Tony van Hasselt

Linkage of Dark and Light Shapes

The sketches on this page show a simplified value breakdown. All the dark values in the subject, grouped together are represented by the black shapes in the sketch, while the white paper represents the various light values. This breakdown of black and white can be observed when viewing the subject — or your work — through half-closed eyes. Try to distance yourself from *what* the subject is and instead concentrate on the abstract patterning of light and dark shapes.

A picture may be perfectly balanced, but if the dark and light shapes are not connected, the result will be spotty. Connecting or linking spots together solves the problem, as seen in the lower version. These areas do not have to actually touch; they may be placed near enough to each other so that a *visual* linkage occurs. Look back at the lettering exercise on page 34 and notice that the letters in "positive" as well as in "negative" are *connected*.

Imagine that the dark areas in the sketch represent land and the white is water. Can you "walk" through the sketch without getting your feet wet or do you have to do some fancy jumping from stone to stone? Next, imagine yourself in a canoe, paddling through the sketch. Can you float through the whole scene or do you have to get out once in a while and tote that canoe? Avoid "trapping" a light area by solidly surrounding it with dark areas. Instead, leave passages or "streams" of light so you can paddle into that area.

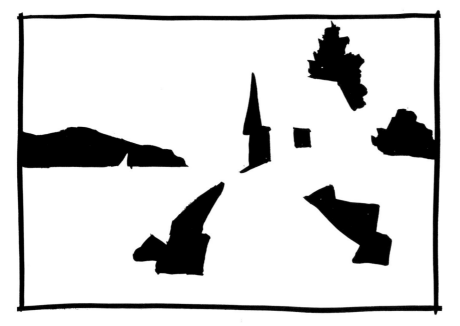

Linkage Exercises

Place your acetate or tracing paper over page 20 and "walk" through each sketch with your brush on the dark (land) areas. Are all the darks connected? Are there any "islands" you cannot reach? Next, let your brush become a canoe in the white (water) areas. Can you float through each sketch? Are there any "trapped" lakes of light you cannot reach? Try this same exercise on the four versions of the barn sketch that you did on page 23.

Next, make two photocopies of this page and with a black felt-tip pen, connect the spotty areas in the top sketch. These connectors could consist of dark trees, bushes, docks, poles, cast shadows, etc. Keep balance in mind, however.

In the bottom sketch, many of the light areas are trapped. On the second photocopy, use white paint and create passageways connecting these areas to other whites.

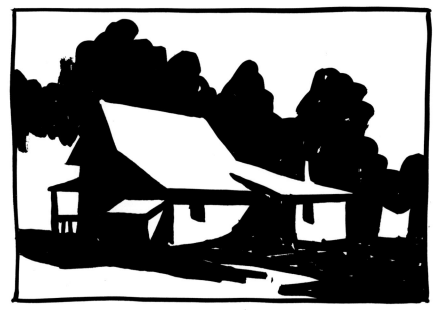

6 Dominance
The Building Block That Unifies

Dominance is one of the most important words to remember when painting because it applies to so many parts of the process. It serves as a warning to avoid anything equal. One part should dominate while the other becomes a subordinate, unchallenging *accent*. Our symbol depicts the most obvious dominance as it applies to space division. Do not place a horizon line exactly in the middle of the painting, giving equal parts to earth and sky. This half-and-half division is to be avoided horizontally, vertically, diagonally and, as can be seen in the coastal scene on page 46, in any free-form manner.

Dominance also applies to values, colors, temperatures, line direction, shapes, edge qualities, and to almost anything. On these two pages for instance, the illustration is dominant and the type is a subordinate accent. Since diagrams are just not the same as actual applications, take a look at how dominance has been applied in our work as well as in some excellent examples supplied by friends and fellow painters.

Temperature Dominance

This scene, painted in a hot and dusty, but utterly charming, little village in Mexico, is a good example of temperature dominance. If one were to ask whether this is a cold or warm painting, the obvious answer is warm.

There *is* the accent of cool in the sky, echoed or rhymed by the blue skirt on the figure. If there is any hesitation in answering such a query, the temperature dominance may be questionable.

Siesta Time
15″ × 22″
Tony van Hasselt

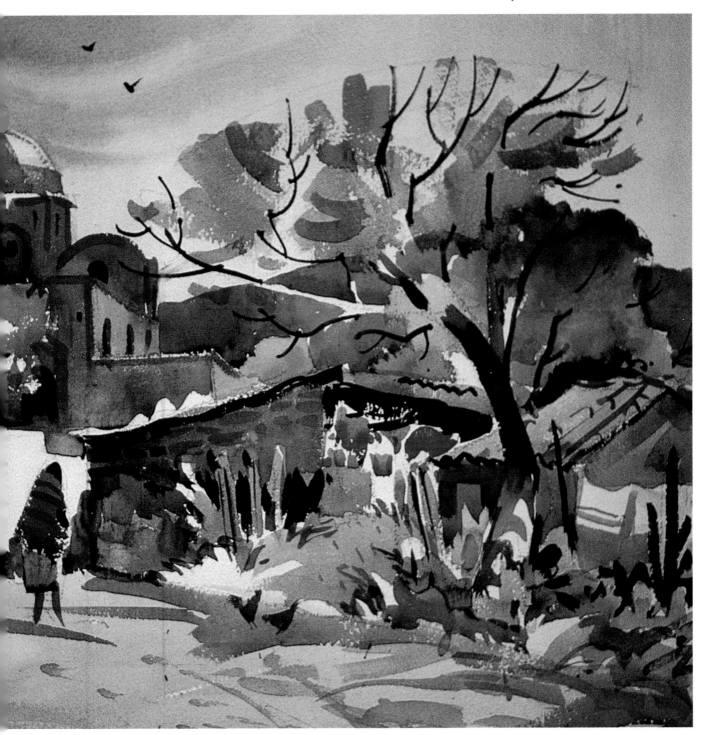

Space Dominance

Hill Country Ranch, below left, as well as *Hill Country Sky*, bottom, are good examples of space dominance. Using the same Texas ranch subject, the first version features a dominant foreground with just a token indication of the sky. In the afternoon, clouds animated the sky, allowing the op-portunity to do another version of the subject, this time using for the dominant space, the sky that's towering over the small ranch buildings.

The coastal scene, below right, is an example of *lack* of space dominance. The land and water divide the space equally, in a free-form manner.

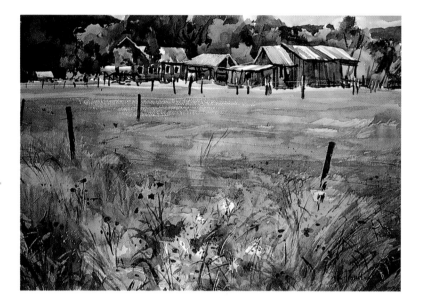

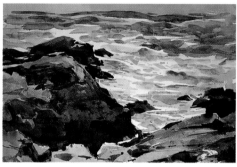

Hill Country Ranch
15″ × 22″
Tony van Hasselt

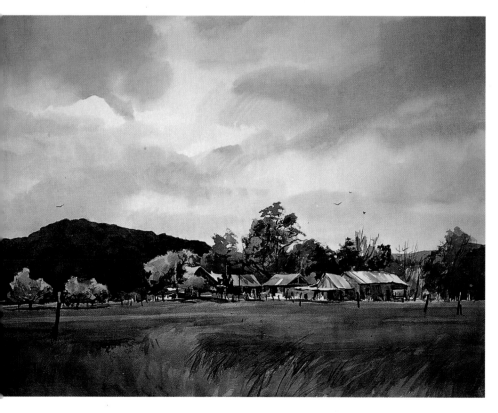

Hill Country Sky
22″ × 30″
Tony van Hasselt

Value Dominance

Jackson Falls is a great example of light value dominance expressing the essence of a rushing stream. The dark accents direct and hold the eye at the center of interest but are well balanced by supporting darks. Another dominance observed here is shape dominance, using curvilinear shapes for the waterfall.

There is no doubt about the value or temperature dominance in *Stacking it in for Winter*. It's dark and cool appearance ties in well with the title, yet is accented with the small spots of light. There are two more aspects of dominance observed here. Note the color dominance of blue-gray and the dominant linear direction which is vertical, although the foreground weeds and foliage come close to challenging that point.

A mid-value dominance was adhered to in *Carmel Mission*.

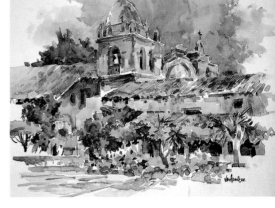

Carmel Mission
15" × 22"
Tony van Hasselt

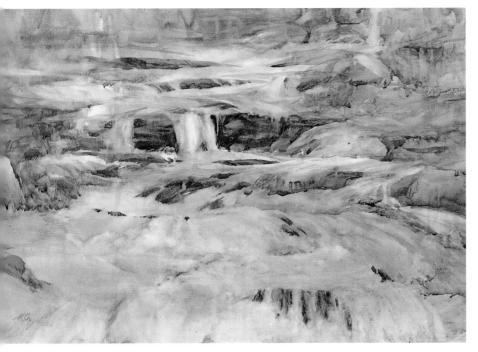

Jackson Falls
22" × 28"
Muriel Doggett

Stacking It In for Winter
15" × 22"
William Condit

Shape Dominance

When we think of Peter Paul Rubens, voluptuous curvilinear shapes come to mind. Piet Mondrian's work evokes rectangular imagery. Similarly, the paintings on this page have a shape dominance *imposed* on the subject by the artist. *Dancing Rhythms* is a good example of curvilinear shape influence. This is not a good example of dominance however, since that all-important accent is missing. One longs for the relief of a fence rail or distant slice of water to establish this accent of a straight line. For some examples of this, look at pages 105 and 128.

A rectangular dominance was imposed onto the *Gisco Dock* subject, which, if it had been treated in a strictly representational manner, would not have been as interesting a subject. The accent of curves may be observed in the calligraphic marks of the rigging, the nets, and some of the grass in the foreground.

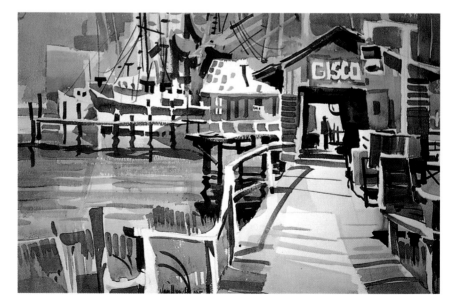

Dancing Rhythms
22″ × 30″
Judi Wagner

Gisco Docks
15″ × 22″
Tony van Hasselt

Color Dominance

As can be seen in the example, below right, a painting will lack unity if color dominance is not observed. One should not have to ask, "Is this a green painting? A red or blue one?"

Color dominance assures unity in our work as may be observed in the two excellent examples, below left and at bottom of page.

Waiting Out the Storm has a clear dominance of blue, accented by the neutralized yellow-orange of the lower left and shadow of the building. *Docking, Port Manatee* features a large, dominant red area. The green accents in the water help to enforce that dominance. To increase color dominance even more, a red glaze can be placed over some of the other areas in this work.

Color dominance is one way to assure unity in your work.

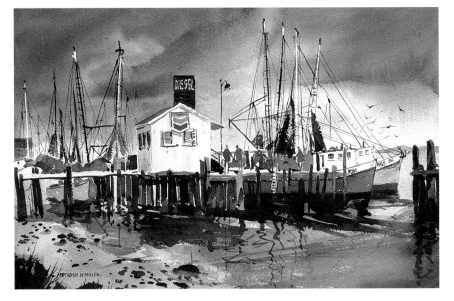

Waiting out the Storm
15″ × 22″
Thomas H. Miller

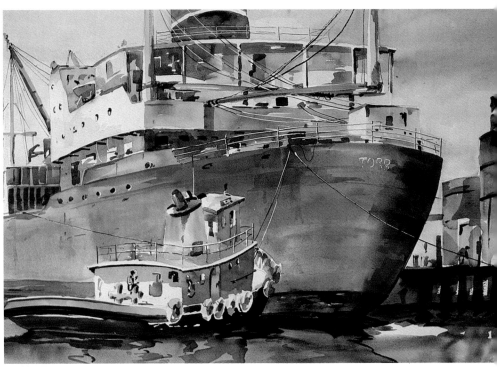

Docking, Port Manatee
22″ × 30″
Jerry McGlish

The Quarry
15" × 22"
Tony van Hasselt

Soft edges dominate this painting, while the knife sharp lead-in forms the accent. Since the watercolor medium does not offer the tactile textural qualities of oil paint, edge variation can give an illusion of texture.

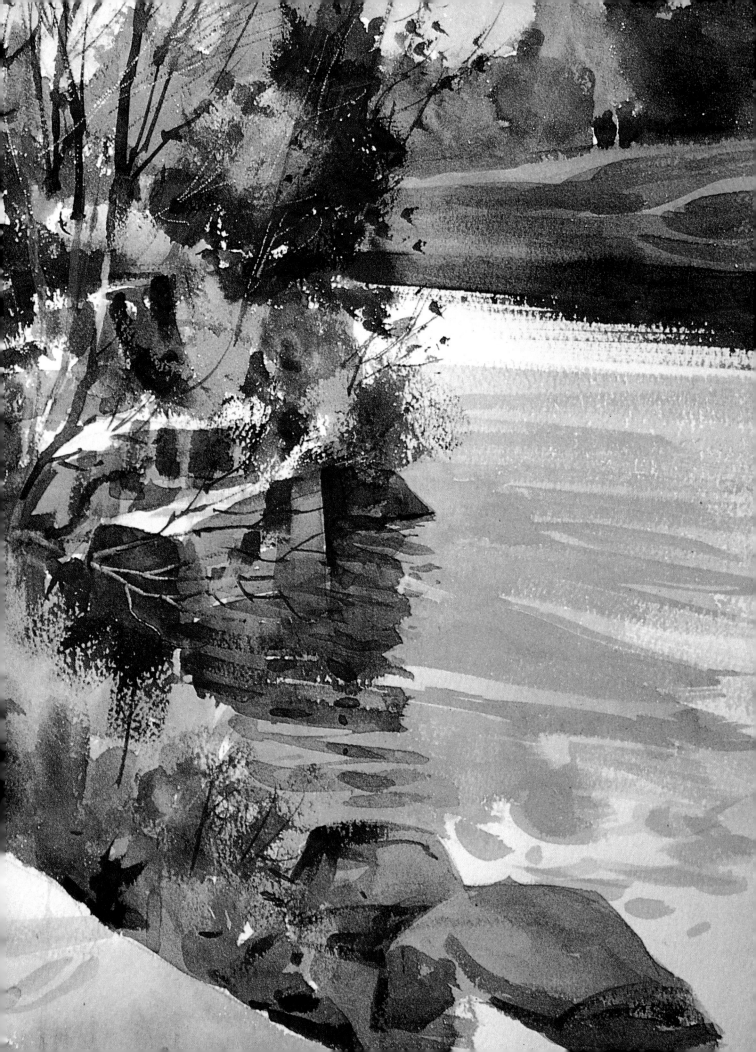

7 Gradation
The Building Block That Adds Excitement

When all planes in a painting are rendered in flat washes, the construction and values may be very solid, but also very predictable and boring. Gradation changes all of that because gradation *is* change. Using the sky as an example, a flat blue wash over a large area could be very amateurish and dull. Such a wash has to be modulated in color and value. Observe the sky; it is quite dark at the zenith and gradates to light at the horizon. The background of our symbol is an example of this type of gradation, while the *G* is an example of reciprocal gradation (discussed later in this chapter).

As the diagram shows, there are other types of gradation.

Again using the sky as an example, observe that opposite the sun, the sky is quite cool, *gradually* changing to warm as it nears it. This is a great way to create more exciting skies, as *Siesta Time* on pages 44 and 45 showed.

The different ways to gradate are: *1* – Gradation from pure color to a neutralized version. *2* and *3* – An analogous slide to a neighboring color on the color wheel. *4* and *5* – The most obvious usage, sliding toward the darker or lighter value of the same color. *6* – Gradation of textures or marks.

Sliding Shadows
15″ × 22″
Judi Wagner

The effective gradation of the lower right foreground forces the viewer to focus attention on the boat.

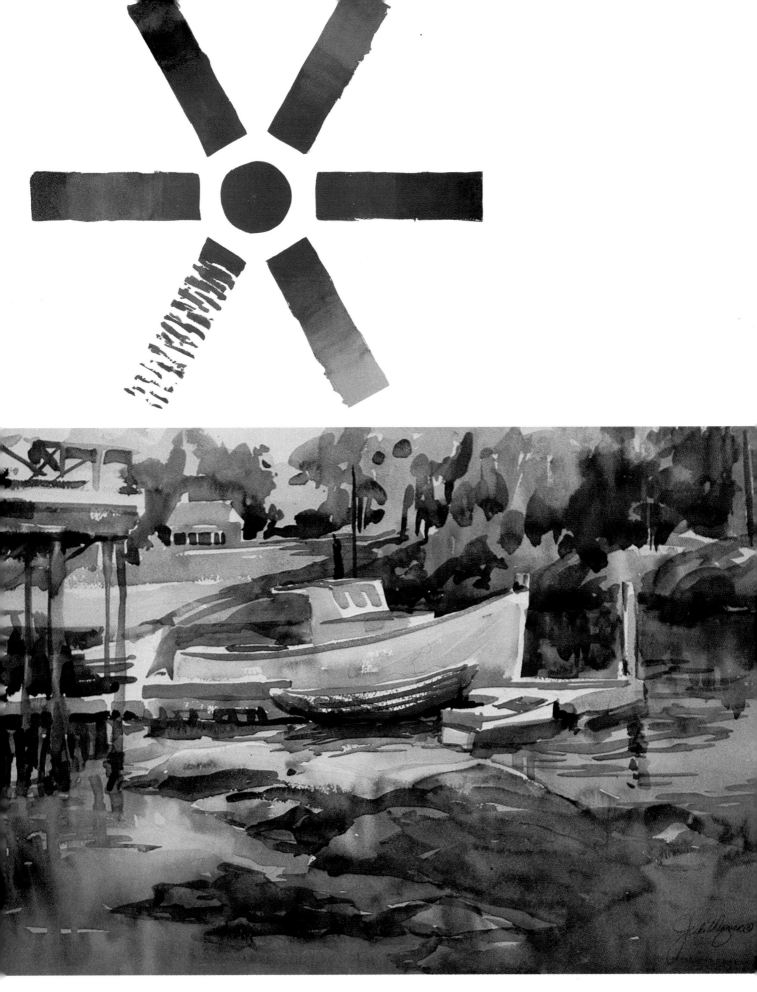

Value Gradation

There are two choices. You can gradually lighten or gradually darken a color. The paintings on this page are good examples of this gradation in action. Normally, the sky gradually lightens as it reaches the horizon. In *Towering Mesa*, however, the gradation effect was *forced* to emphasize the height of the cliff, as if the viewer were looking straight up into the zenith.

Since water reflects the sky, there will be opportunities such as those observed in *Monhegan Cliffs*, where the water will be the lightest at the horizon and darken as it comes toward the viewer. This gradation is not a rule, but works very effectively when a large part of your painting needs to be animated.

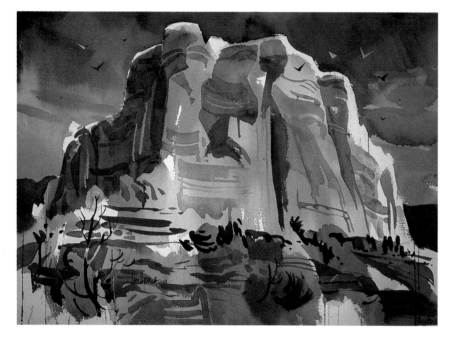

Towering Mesa
22" × 30"
Tony van Hasselt

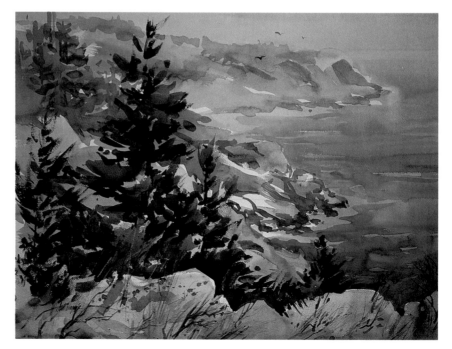

Monhegan Cliffs
22" × 30"
Judi Wagner

54

Chromatic Gradation

To direct the eye to the center of interest, the brightest version of a color can be placed near that focal point, while a gradual neutralization can occur as that color nears the edge of the painting. To some extent, this technique was used in *Monhegan Light* and helped to animate the large piece of foreground. Another example is *The House Remembers*, on page 75.

Textural Gradation

The Price Is Right features a series of foreground marks that quickly diminish in size and frequency, helping to enliven the foreground and getting the viewer's eye across it to the center of interest. It is good general advice to keep texture in the foreground and to gradually decrease it as you proceed deeper into the distance.

Monhegan Light
22″ × 30″
Judi Wagner

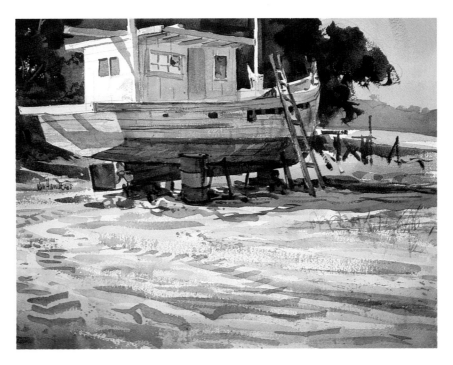

The Price Is Right
15″ × 22″
Tony van Hasselt

The Sugar Shack
22" × 30"
Judi Wagner

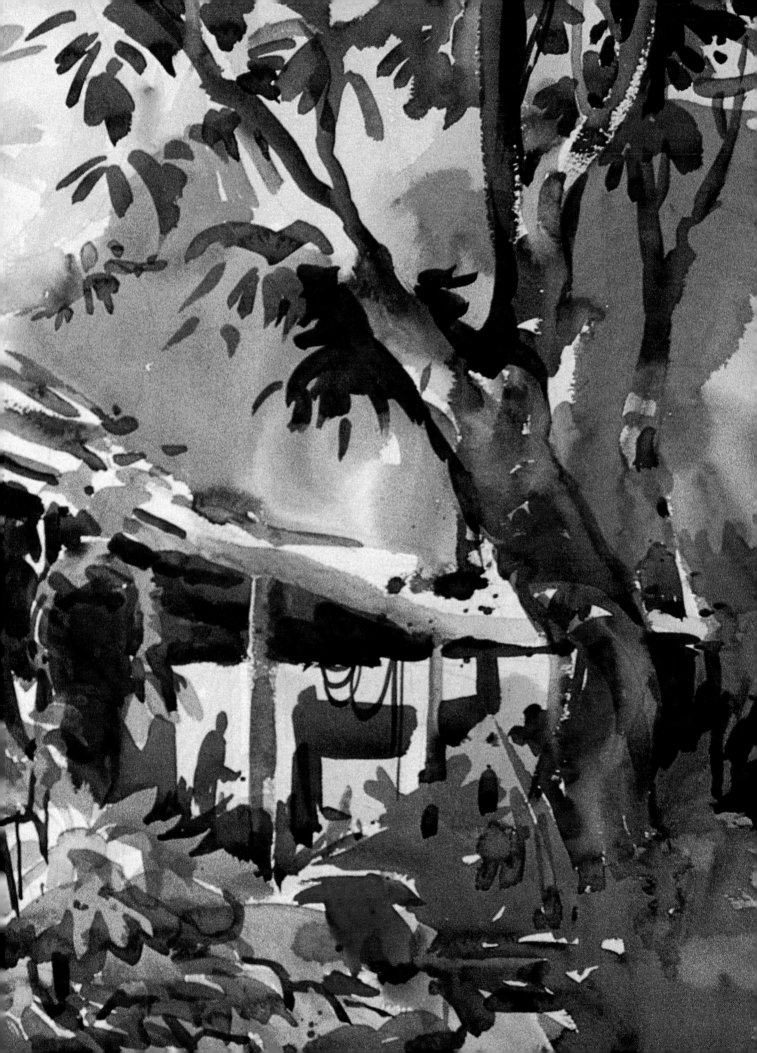

Analogous Gradation

When an orange is placed next to a red, as shown in the two background slices of *The Sugar Shack*, we use a *neighboring* color on the color wheel to animate an area. In the heat of the on-location painting battle, this is a safe way to modulate colors instead of veering wildly and haphazardly across the palette. Note also that in each case, the opposite color is introduced in some small measure as an accent.

Details from *The Sugar Shack*, pages 56 and 57.

Reciprocal Gradation

The effect of reciprocal gradation is best illustrated by our symbol. Note how the lower half of the G is dark against a light background and the top half is light against a dark background. This phenomenon can constantly be observed in nature. The photograph shows a light-valued trunk against a dark background. This same trunk takes on a dark value when silhouetted against the light sky.

In the *top right* detail, reciprocal gradation was used to full advantage on the sunny building. Against the sky, we see a dark building, and towards the bottom, against a darker background, the same building tone is lighter. This technique was very subtly used in *Oaxaca Portal*, as the enlarged section shows.

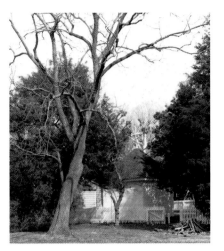

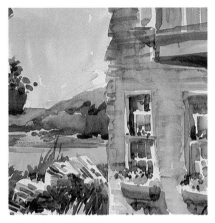

Oaxaca Portal
15″ × 22″
Tony van Hasselt

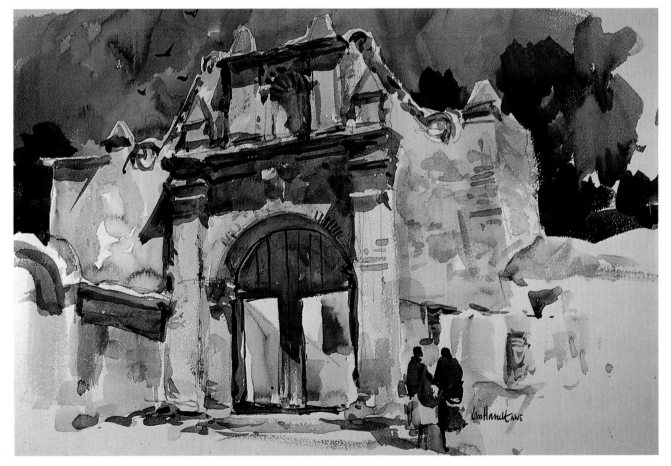

8 Depth

The Building Block That Adds Dimension

The word *perspective* can bring fear to the mind of the beginning painter, who visualizes lines going in all directions. *Linear* perspective is, however, only a small part of the task of creating depth in your work. Linear perspective is needed for the person who *constructs* a scene—an architect or set designer. The average painter *facing* the subject needs to know how to draw, how to relate shapes to shapes, which has little to do with the boring rules of linear perspective. This chapter concentrates on the effects of *atmospheric* perspective.

Air is visible. Just take a drive through the mountains and see the effect it has on them. The most distant range is so much lighter in value than those close to us. Our symbol was inspired by this effect—the layers of atmosphere filtering and changing those things seen through them. The atmosphere affects values, colors, edges and textural details, as examples in this chapter will show.

Take a look at *nine* ways to simulate a three-dimensional feeling on a two-dimensional surface—all without having to resort to linear perspective.

You can create depth in your paintings in at least nine painterly ways without using linear perspective.

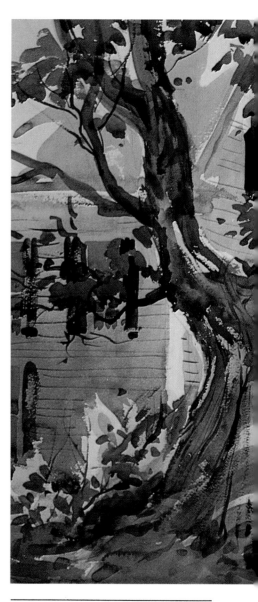

Behind the Inn
22″ × 30″
Judi Wagner

60

Creating Depth With Textural Changes

Use texture in the foreground or in the center of interest. Treat all other areas with textural restraint. In *Behind the Inn*, attention focuses on the tree, which was lavished with textural details. The building is a secondary, background shape because of the textural *restraint* in that area. The air between the tree and the house truly exists. This feeling of "air" between the tree and the house truly exists. This feeling of "air" between things is accomplished by *not* painting details on a background shape, as the two details dramatically show. Conversely, depth is destroyed when the background has as much textural detail as the foreground.

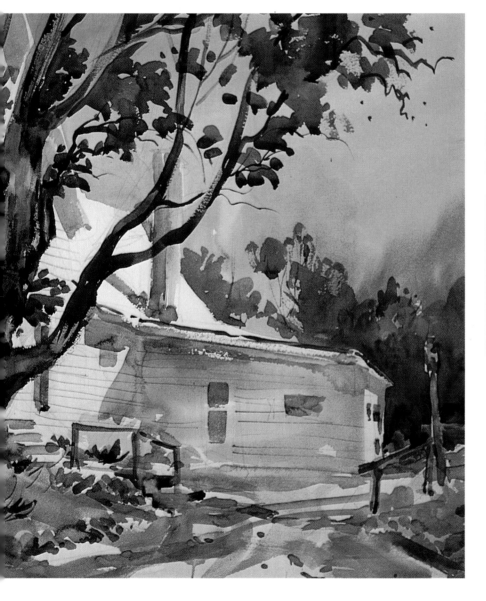

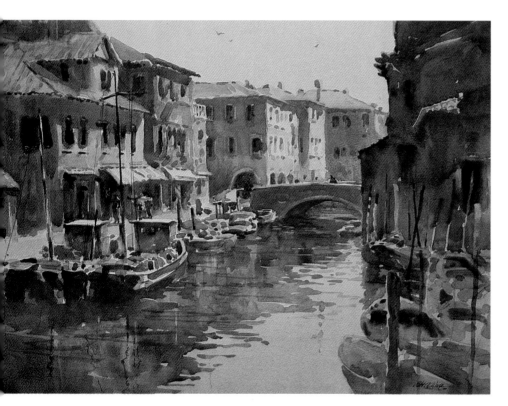

Creating Depth With Chromatic Changes

Color becomes less intense as it recedes into the distance. The rooftops in *Chioggia, Italy* serve to demonstrate this point. Note the intense colors used on the foreground tiles and the decrease of intensity as they recede. Even on areas that are near to each other, as seen on the roofs of *The Candy Lady's House*, colors can be slightly separated by neutralizing the distant one.

Chioggia, Italy
20″ × 30″
Robert Wade

The Candy Lady's House
22″ × 30″
Judi Wagner

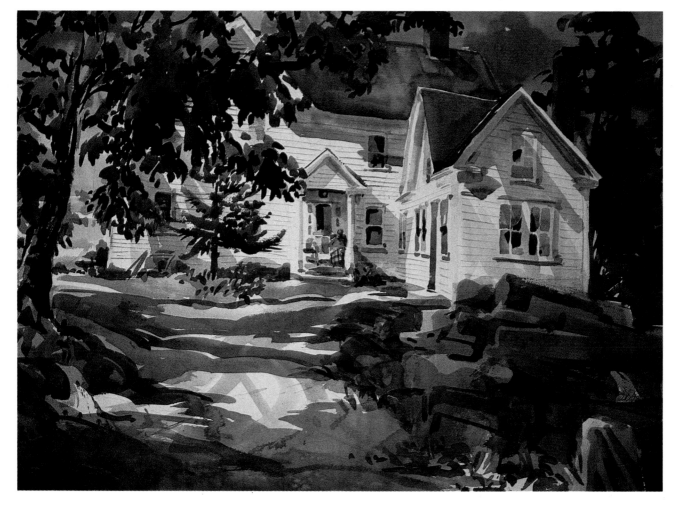

Creating Depth With Value Changes

Values can become lighter as they recede. This is a sure way to create the feeling of depth and can be emphasized in rainy and foggy scenes such as *Rainy Day in Freedom*. Note how the trees change color and value in the distance. Of course, due to weather conditions, there can be exceptions to this lightening of values. Look at these points as guidelines instead of definite rules.

In *Mountain Stream*, the actual value of the background foliage was virtually the same as the foreground tree. However, to emphasize distance, a lighter value was forced onto that area.

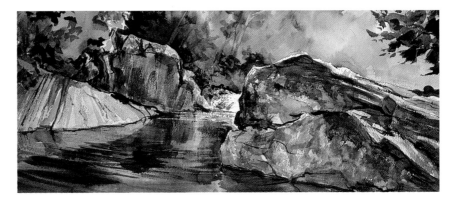

Mountain Stream
10″ × 22″
Tony van Hasselt

Rainy Day in Freedom
22″ × 30″
Tony van Hasselt

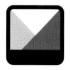

Creating Depth by Overlapping Shapes

When shapes overlap, it creates the feeling of stepping back into the painting, as is clearly demonstrated in *Fish Houses* and in a more subtle way in *View from the Top*. In this last painting, the foreground fence overlaps the tree shadow, the tree overlaps the in-let, distant island, sea and sky beyond. The house structure overlaps others, which in turn overlap the island. There is always something in front of or behind the objects in a scene. To paint this overlap is one way to paint the third dimension. When this is not done, the objects become isolated and the viewer does not know where to go next.

Fish Houses
22″ × 30″
Judi Wagner

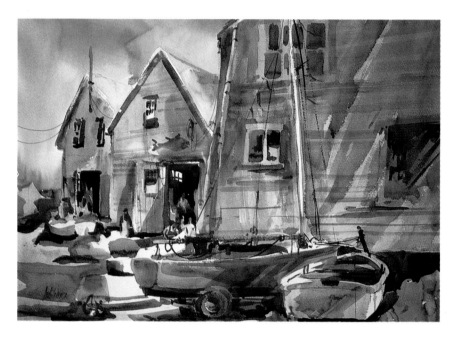

View from the Top
22″ × 30″
Judi Wagner

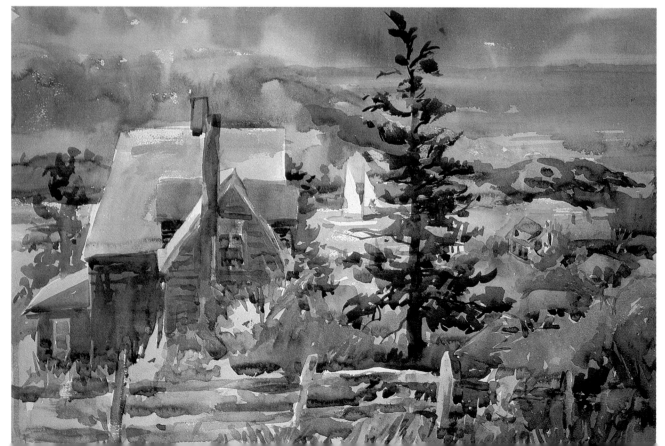

Creating Depth With Edge Changes

Hard edges come forward and soft edges recede. Ron Ranson's *The Bridge*, at right, is a great example of this phenomena. The hardest edges are reserved for the tree, while the bridge is softer and the distant foliage has the softest edge. In *Jenny Lake*, the hard-edged quality of the tall stand of pines on the right is in sharp contrast to the soft-edged mountain behind it.

The Bridge
14″ × 18″
Ron Ranson

Mist over Jenny Lake
15″ × 22″
Tony van Hasselt

Creating Depth With Color Temperature

Warm colors come forward while cool colors recede. Although the atmosphere affects and filters colors, vibrations caused by the color energy itself make red and orange, for instance, appear in front of cooler colors such as blue.

In *November Hues*, the artist reserved the coolest blues for the most distant mountain range. She did use a red in the middle range, but in comparison to the red used in the foreground range, it is much cooler. This was accomplished by adding blue to the more distant red. Similarly, in *Cathedral Overlook* blue colors were reserved for the sky and mountain backdrop, while warm ones were assigned to the church structure.

November Hues
22″ × 30″
Polly Gott

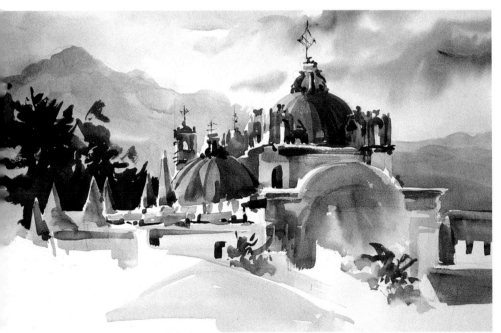

Cathedral Overlook
22″ × 30″
Judi Wagner

Creating Depth With Directional Lines

Having shadows move *into* the painting, as seen below in *Sugar House, Grafton, Vermont*, is a major help in establishing depth. Don't automatically paint the shadows as they are. Instead, direct them so they increase the three-dimensional feeling. *After the Rain* uses a similar directional technique with the road textures assisting the eye to focus deeper into the painting. This technique is used in several other paintings in this book. Can you find them?

After the Rain
15″ × 22″
Tony van Hasselt

Sugar House, Crafton, Vermont
22″ × 30″
R. K. Kaiser

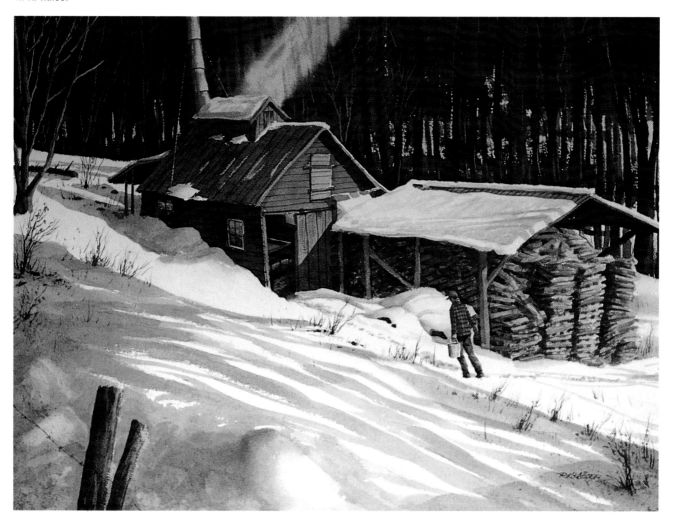

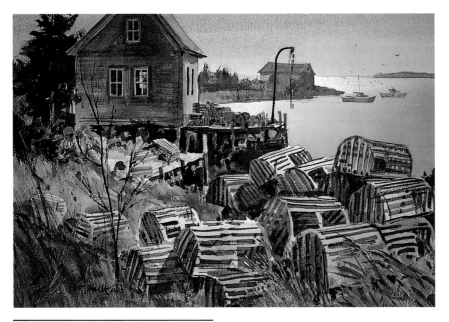

Creating Depth With a Diminishing Repeat

A specific-sized object, repeated smaller, will appear further away. This three-dimensional device is constantly used with telephone poles, people, and, as in *Epworth Gate*, with a fence diminishing in size as it moves deeper into the painting. In *Vinalhaven Afternoon*, the foreground lobster pots are repeated much smaller in the middle distance. Even the smaller repeat of the foreground structure helps create a feeling of depth. Look for additional examples of this device in action.

Vinalhaven Afternoon
15" × 22"
Tony van Hasselt

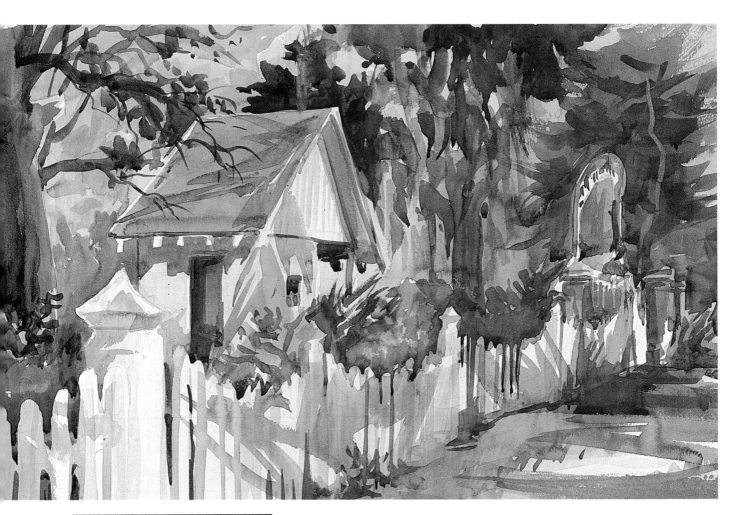

Epworth Gate
22" × 30"
Judi Wagner

Creating Depth With Gradation

One last, very effective way to create the feeling of depth is by using either value or textural gradation. In *View from Artists' Point*, the foreground gradates toward the distance. Other examples of this method can be seen in *Towering Mesa* and *Monhegan Cliffs*, on page 54. Textural gradation helped create depth with *The Price Is Right* on page 55.

The Challenge of Painting Air

Compare the two paintings at bottom, and note that in the one on the left, a feeling of space exists between the two buildings. This feeling is lacking in the scene on the right. Using the techniques discussed in this chapter, analyze what went wrong. How would you repaint the scene on the right to emphasize the existence of air between the buildings?

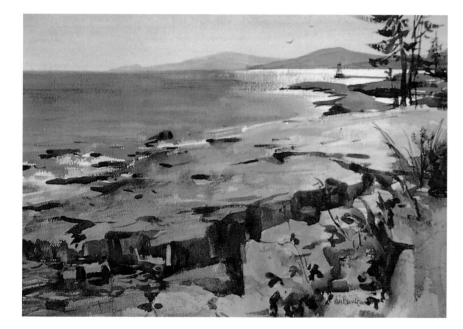

View from Artists' Point
15" × 22"
Tony van Hasselt

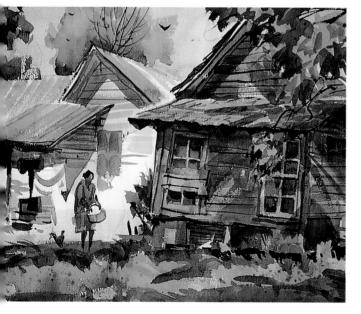

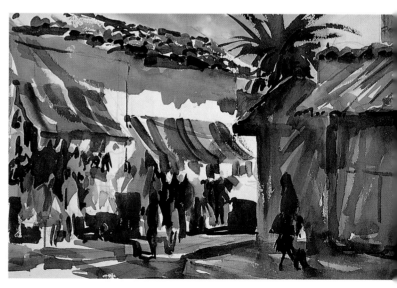

9 Focal Point
Our Final Building Block

We have purposely kept the focal point, or center of interest, as the last symbol to discuss, since many of the other building blocks are used to achieve that center of interest, directing the viewer's attention to it. The above symbol shows, for instance, that *gradation* can be used to direct the eye. It shows that *alternation* of value is needed at the focal point. The *dominance* of the rectangular design has a circular accent *shape* at the center of interest. As a final reminder, the arrows locate placement of the focal point.

Whatever the viewer's eye is attracted to first in a painting is the center of interest, and nothing else should compete as strongly for that interest. Compare the work to a stage production for which *you* are the lighting director. You must be sure the spotlight is on the major star and not misdirected to unimportant areas on the stage. This chapter discusses where to place the focal point and how to direct the viewer's attention to the star of the show.

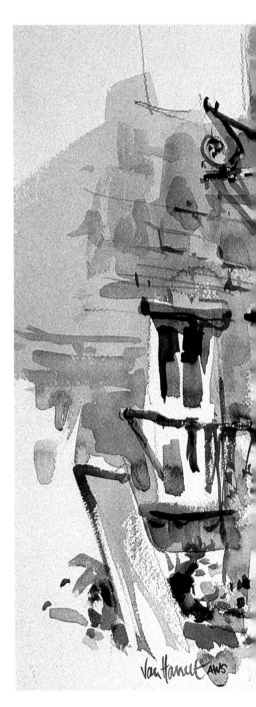

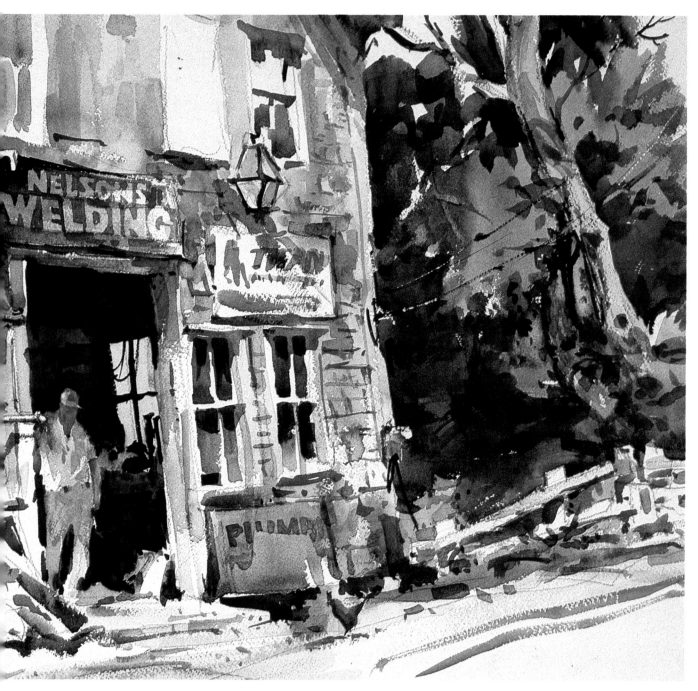

The Unexpected Visitor
15″ × 22″
Tony van Hasselt
Collection of Mr. and Mrs. Gordon Sanborn

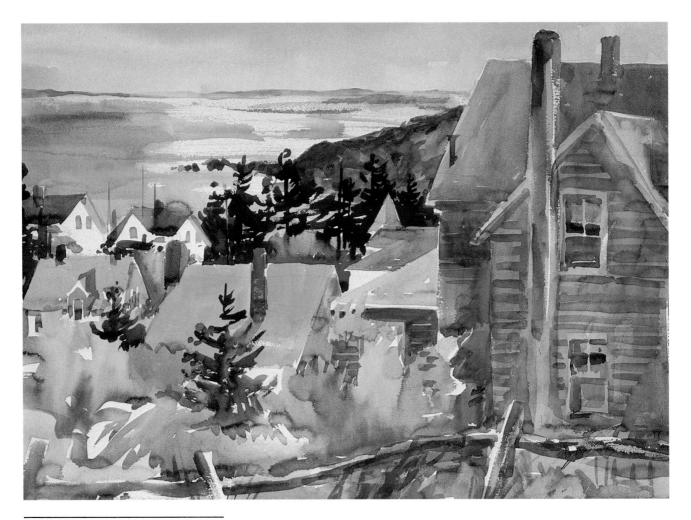

Beyond the Village
22″ × 30″
Judi Wagner

Edifice Mex
15″ × 22″
Tony van Hasselt

Where to Place the Focal Point

Where to place your star of the show is crucially important. Never place it in the center of the painting, nor too close to any one of the edges.

During the course of history, several complicated placement methods have been developed. The easiest one is the "Rule of Thirds," shown at left. Simply divide the edges of the paper into thirds and *wherever* the dividing lines cross is the ideal spot for the center of interest. Decide which cross point is most suitable for the chosen subject and you're ready to go. For instance, in *Beyond the Village*, the focal point is placed in the upper left corner, while in *Summer Barn*, the placement is in the upper right.

Directing the Eye With Value Contrast

Place the darkest dark against the lightest light at the center of interest. In *Beyond the Village*, the viewer's eye is forced past all the structural detail directly to the dark headlands against the light sea. The other parts of the painting play just the right subordinate role, with enough detail to satisfy the secondary look, yet not detracting from the focal area. In *Edifice Mex*, bottom left, the same technique is used to force the eye to the front of the church.

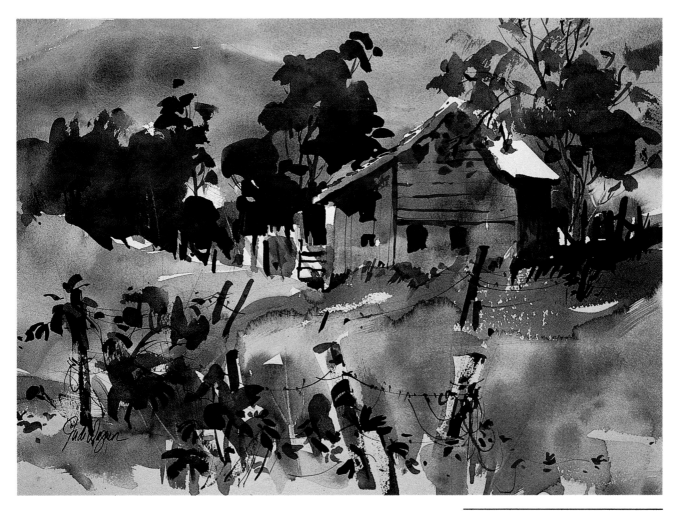

Directing the Eye With the Accent

Place the accent color or value near the center of interest. In *Summer Barn*, the dominant color is a variety of greens and blues, while in the focal point the accent of a very warm red is used. In *Inside the Mill*, the dominant value is dark and the dominant temperature is warm. The window and material catching the light are placed at the focal point and the blue paint can is used as a cool accent in that same area.

Summer Barn
15″ × 22″
Judi Wagner

Inside the Mill
15″ × 22″
Tony van Hasselt

Directing the Eye With the Human Element

Figures should be placed at or near the focal point. Since the viewer identifies with them, they automatically become the center of interest in a landscape. Normally, a large piece of white would attract the attention in a painting such as *Tzintzuntzan*. In this case, however, the eye does *not* go to the white church dome first, but instead identifies with the figures in the foreground. In *The Hard Place*, there are no figures in the painting. Here the human element consists of the house and your eyes are automatically drawn to it, despite all the foreground detail.

Tzintzuntzan
15″ × 22″
Judi Wagner

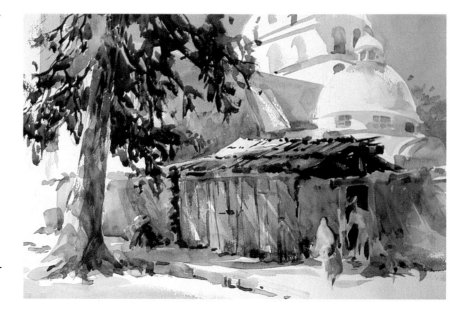

The Hard Place
15″ × 22″
Tony van Hasselt

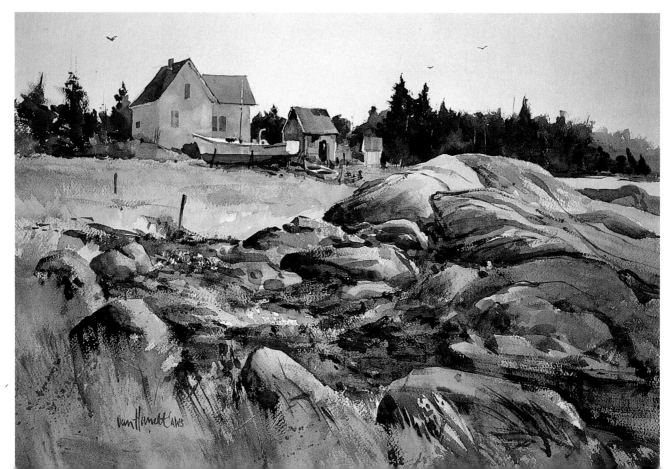

Directing the Eye With Chromatic Contrast

Place the most intense color at or near the focal point. For example, in *The House Remembers*, the most intensely colored grasses were placed near the building. Colors become more muted as they near the edge of the painting. In *The Sunny Spot*, Herbie Rose cleverly interweaves the intense colors of the flowers around the lawn chairs. The subject is the combination of both.

The Sunny Spot
11″ × 15″
Herbie Rose

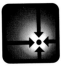

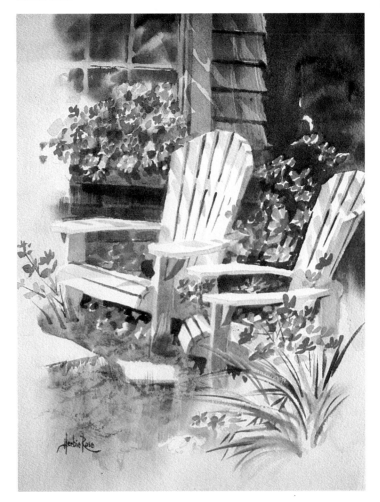

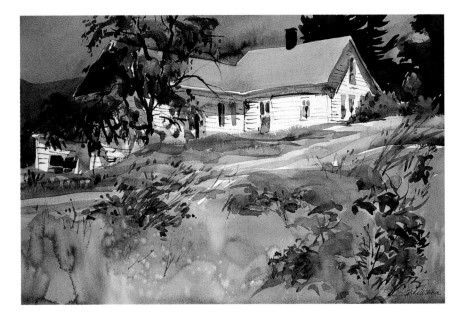

The House Remembers
15″ × 22″
Judi Wagner

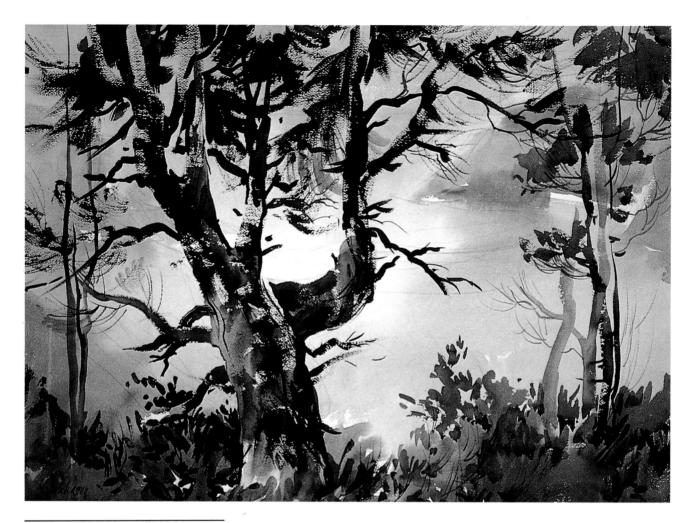

Misty Cove
22" × 30"
Judi Wagner

Your pictures will have more impact when you intentionally direct your viewer's attention, rather than leaving it to chance.

Directing the Eye With Surface Detail

Place the most surface detail at or near the focal point. The top two paintings were selected to demonstrate their similar subject matter, yet amazingly different reaction to the center of interest. Although both are successful paintings, in *Misty Cove*, the viewer's eye focuses on the dominant tree with its surface textures and nothing competes with this focal point. In *Purity Lake*, on the other hand, the major tree still attracts the attention, but the eye wishes to flick back and forth between the distant addition of the human element and that beautifully rendered tree. Similarly, in *The Hard Place*, on page 74, the eye flicks back and forth between the foreground rocks and the

house. The moral of the story is: If the danger of two competing subjects exists, place them near each other or overlap them as was done in *The Sunny Spot*, shown on page 75.

In *Cape Neddick*, the boats are the subject; they are the human element in this work. In addition, the artist forced the viewer's eye to look at this subject even more by lavishing surface textures and excitement on that area. Surface details were decreased as he neared the edge of the painting.

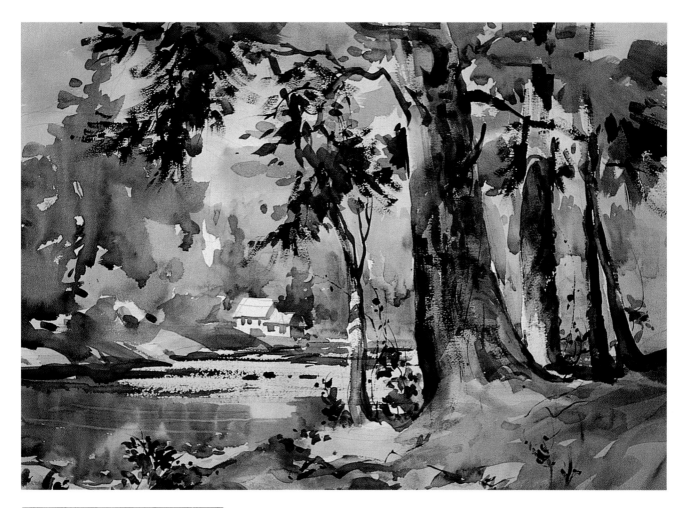

Purity Lake
22″ × 30″
Judi Wagner
Collection of Mr. and Mrs. Gordon Sanborn

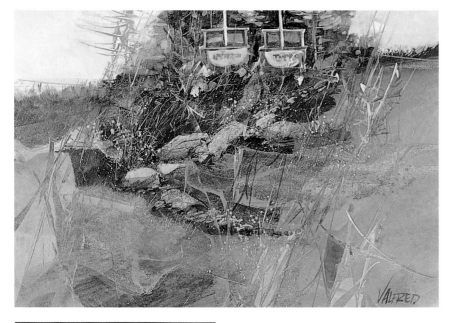

Cape Neddick
22″ × 30″
Valfred Thelin

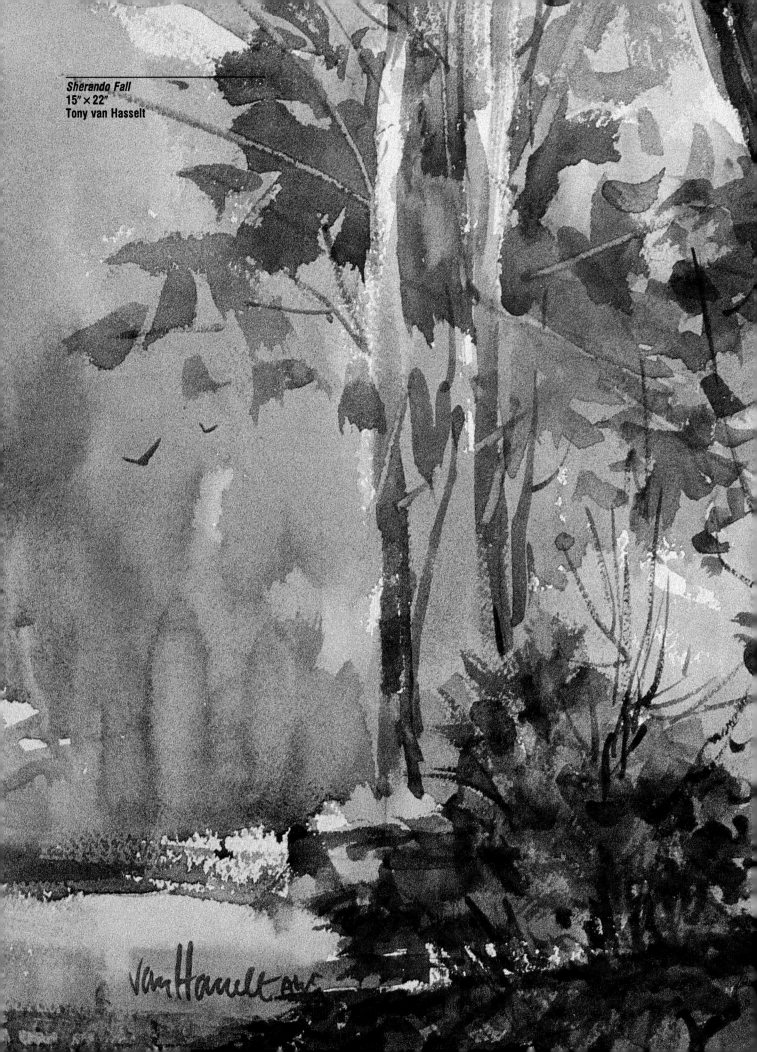

Sherando Fall
15″ × 22″
Tony van Hasselt

10
Color Observations

It is easy to subdue an overstated color, but almost impossible to brighten a dull one.

Our *value* symbol makes one aware that colors of different values need to be used. *Alternation* brings that point home even more by emphasizing that a light-colored area must be placed next to a darker one. The *shape* symbol reminds you that color is important but a clear shape is vital. *Balance* teaches that a color must be repeated elsewhere in the painting, while color *dominance* advises the use of a major color theme and warns against the use of too many different colors. *Gradation* in color can slide from light to dark, from bright to dull, from warm to cool. *Depth* couldn't be achieved without proper use of color and the intense or accent color placed at the *focal point* directs the viewer's eye to it.

All our symbols deal with color in one form or another, yet here is some general advice applicable to the watercolor painter.

The Complementary Color

Colors opposite each other on the color wheel (complementary colors), when placed side by side, greatly enhance each other. A good example of this is seen in *Sunlit Mesa*, where the vivid blue sky is placed next to the orange mesa. It is good to use this technique at the focal point. Interestingly, when opposite colors are *mixed* together or glazed over each other, instead of being placed side by side, they neutralize or dull one another.

How to Find the Complement

It is important to know which colors are opposite each other. However, if you can't visualize the color wheel, there is an easy way to find that elusive opposite or complementary color. Remember there are only three basic or primary colors represented by the single squares on our wheel: red, yellow and blue. Now cover that wheel with your hand and read on. *To find the complementary color, just search for the one*

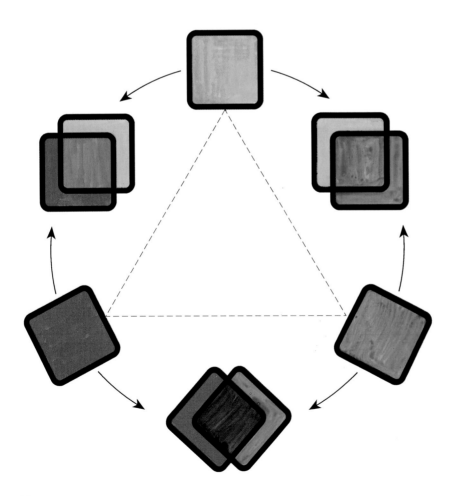

80

or two missing primaries that complete the trio. To find the opposite of blue, know that blue is *one* of the primaries and the *missing ones* are red and yellow. Mixing those two missing primaries will produce the complement of blue, which is orange. If you wish to place the opposite next to green, remember that green is a *mixture* of two primaries. A peek at the *overlapping* squares on the wheel shows them to be yellow and blue. Consequently, the missing primary is red—the complement of green. Without peeking, which primary is needed to complete the trio if you have violet? Check your answer by looking at the color wheel.

Start More Colorfully

In this transparent medium it is best to overstate color, since a neutralizing glaze can always subdue an area that turns out to be too vivid. It is easy to subdue an intense color. It is *impossible* to change a subdued color into a vivid one, since the paper underneath is no longer white.

Mix on the Paper Instead of the Palette

Another common problem is mixing the exact color *on the palette* and then applying that color to the paper. Overmixing prior to the application results in an overall dull, gray appearance. If the habit of mixing a variety of colors *on the paper* can be developed, the result will bring a more lively look to your work. Take a look at the next page and *The Shackford Place* on pages 86 and 87 for some good examples.

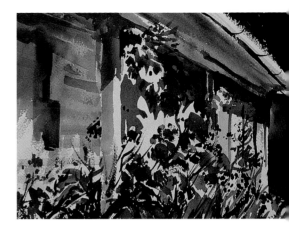

Corner View
9" × 12"
Judi Wagner

Sunlit Mesa
15" × 22"
Tony van Hasselt

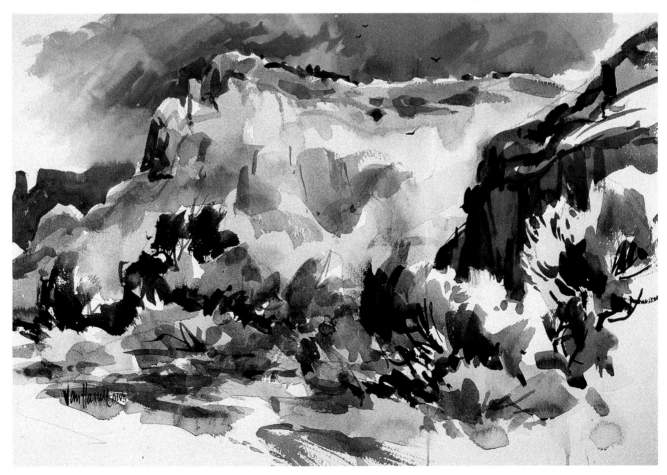

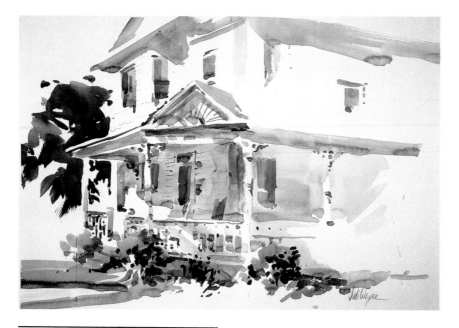

Reflected Light

Many watercolorists have the tendency to render all shadow sides of buildings as blue or gray washes, ignoring the wonderful effects of reflected light. In contrast, *Mr. Askin's Porch* is a great example of reflected light keeping the shadow area alive instead of boring the viewer with a heavy and dull gray wash. Take the opportunity to liven up a shadow area with luscious color mixed directly on the paper. Look for the warmth of a floor or ceiling reflection in that shadow area. Soon you will see those subtle influences of reflected light, especially on planes that directly reflect the earth. *Corner View*, on the previous page, is a good example of that.

Mr. Askin's Porch
22″ × 30″
Judi Wagner

Detail of *Mr. Askin's Porch.*

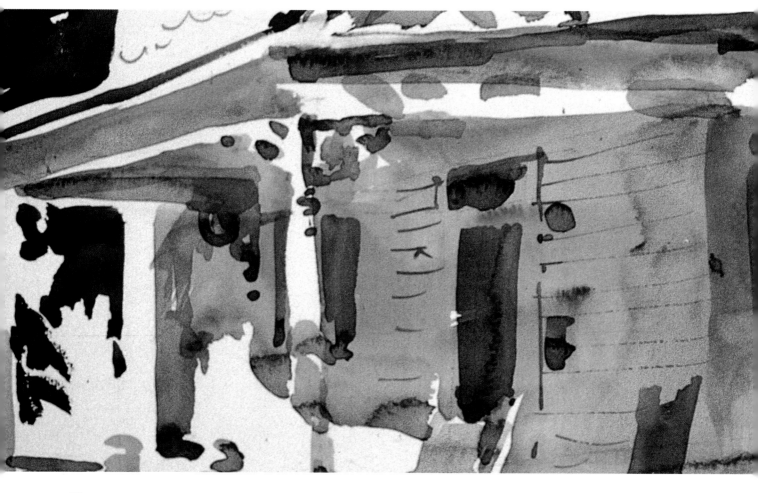

As the diagram shows, when there are two planes in shadow, color mingling can be soft edged in inside corners, while hard edges and distinct temperature changes can occur at protruding corners of those planes.

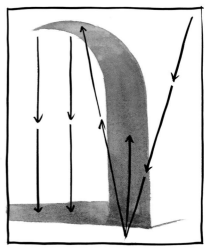

Shadow Color

"What color should I paint my shadows?" is a commonly asked question. The diagram of the archway shows that ground shadows reflect and are influenced by the sky. These shadows tend, therefore, to be cool. Shadows on upright planes are influenced by the light reflecting from the sunny earth and are generally warm. Shadow areas directly opposite the sunny ground plane receive the most direct reflection and are, therefore, warmer and most colorful. Above all, shadow *values* must be convincingly dark, especially at their edges.

Sap Green

Phthalocyanine Green

Cadmium Yellow
and
Sap Green

Cadmium Yellow
and
Phthalocyanine Green

Cadmium Orange
and
Sap Green

Cadmium Orange
and
Phthalocyanine Green

Alizarin Crimson
and
Sap Green

Alizarin Crimson
and
Phthalocyanine Green

Burnt Sienna
and
Sap Green

Burnt Sienna
and
Phthalocyanine Green

Manganese Blue
and
Sap Green

Manganese Blue
and
Phthalocyanine Green

Ultramarine Blue
and
Sap Green

Ultramarine Blue
and
Phthalocyanine Green

Mixing Nature Greens

Green can be a great stumbling block for the landscape painter. Some artists don't even place it on their palette, preferring to mix a green instead. We *do* use green and find that it makes little difference what name is on the tube, as the color swatches on the left indicate. Success lies in the awareness that nature greens are very warm and generally quite muted. *Starting* with a color and adding green to that mixture is the right procedure and constant changing of the mixtures creates variety. The use of gray and red areas in your foliage adds life and sparkle.

Learn to distinguish between nature's warm and muted greens and the cold, acidic, manufactured greens. These two paintings offer a good example of these differences, as can be seen on the roofs and surrounding foliage.

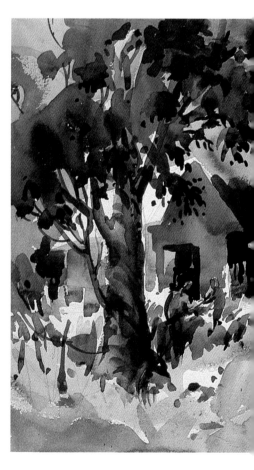

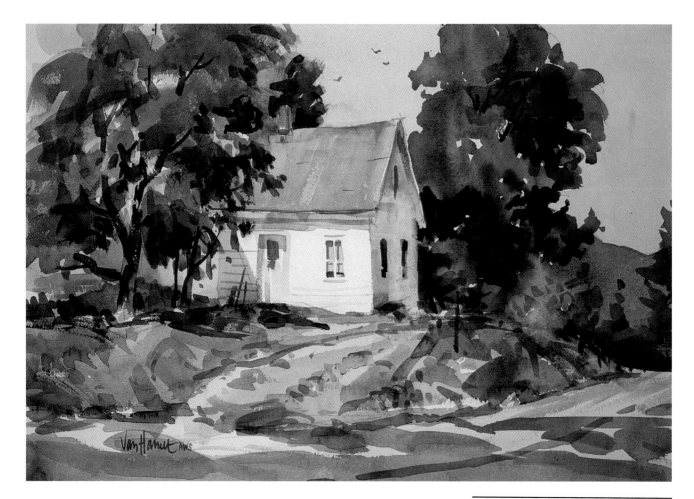

The Quiet Place
15″ × 22″
Tony van Hasselt

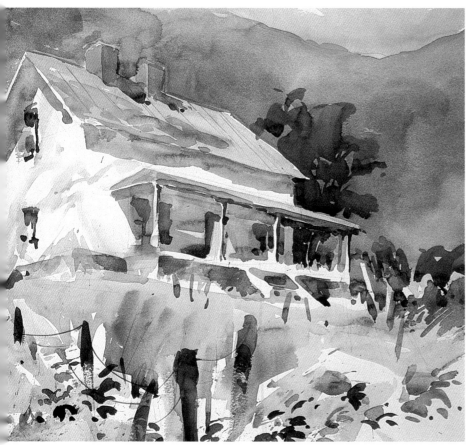

North Carolina Homestead
16″ × 30″
Judi Wagner

The Shackford Place
22" × 30"
Judi Wagner

Section Two The Building Blocks in Action

In the first section of this book, you became reacquainted with the major principles of picture making. In this last half, these principles are used to judge and improve paintings that, for one reason or another, were never finished. Ask yourself the following questions: What is wrong with that painting? Why did I lose interest? Can I put my finger on the problem? What would it take to fix that piece and turn it into something more exciting?

Those are a few of the questions to be addressed visually. We will dig out examples of less successful work and take a look at some "problem children" loaned to us by friends and students. We have tried to pick commonly recurring problems and hope that they are similar to the ones you experience in your own work. It is our hope that these suggested solutions may, in turn, help to rescue and revitalize your watercolors. Yes, they *can* be fixed.

Your attitude is crucial at this point. Try to have a detached feeling when working with your problem paintings, as if they were the works of someone else. Students can be so hard on themselves, becoming so discouraged, angry, and disgusted with work that, from a detached viewpoint, is really not as bad or unsalvageable as it seems. Substitute analytical reactions for negative ones. Don't say, "This is terrible." Instead, ask, "What is wrong here? Why doesn't this work? How can I fix it?"

And of course, the workable acetate gives you a chance to actually preview any corrections or additions. So in this section, let's have some fun looking at our less successful efforts and see if ways can be found to salvage them. Who knows, there might be some potential beauties here.

11
Strengthening Values and Clarifying Planes

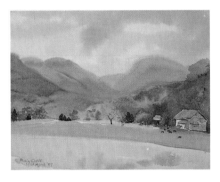

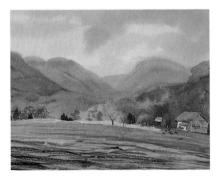

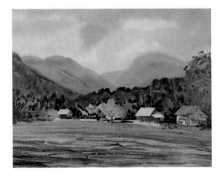

Commonly, beginners get discouraged and stop because they judge a painting too early in the game. Looking at all those weak, diluted washes, it is easy to forget that this is a normal *stage* in the painting, requiring the addition of darker values. Just take a look at the first stage of the painting on page 109. It too has all those light washes.

In this mountain scene, the sky is nicely established and the distant blue range is just the right value and color, but those same light washes were used in the foreground as well and as a result, the work lacks strength. To fix this painting, the next, darker stage has to be added.

With the acetate placed over the work, a darkening gradation is painted over the valley floor. Next, a slightly darker value is glazed over the mountain range to create a better layering and to establish a harder edge. An even darker value is placed over the trees to clearly separate the valley floor from the mountains. The house, located too close to the edge, is diminished in importance by placing foliage in front of it and by introducing other buildings at a better place in the painting. Finally, the fence posts enliven the foreground and lead us into the painting.

Note that the actual painting is not altered. All these suggested improvements are painted on the acetate, giving us a good visual preview of what can be done.

The Solution

The addition of darker values, gradation, and a focal point placed in a better location.

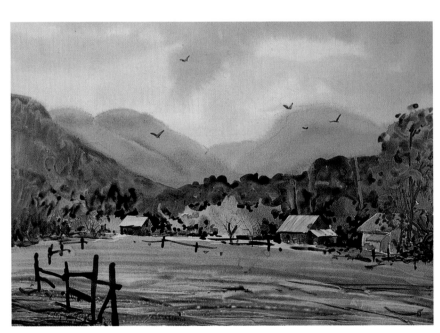

Clarifying Planes

This watercolor was quickly and spontaneously executed from an on-location sketch. It is well executed and the suggested changes are minimal. However, squinting at the two close-ups on the right, you will see that too many of the values are the same, like the roof and the vertical wall, and the roof and the foliage. This confuses the different structural planes. If you squint at the pattern sketches on the far right, the planes become clear. This is a good example of checkerboard alternation and, again, stresses the importance of that pattern sketch. Being limited to mid-value gray and white, you are *forced* to think of clear and simple shapes. All shadows are recorded, and planes receiving sunlight remain white paper.

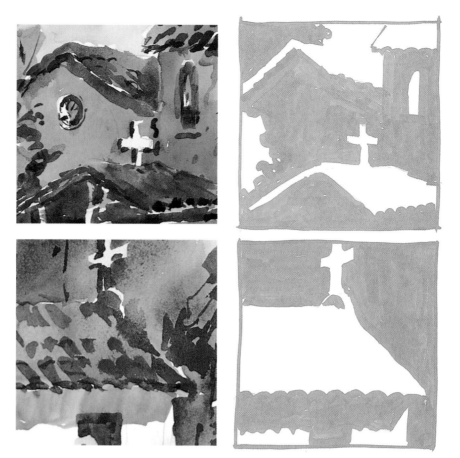

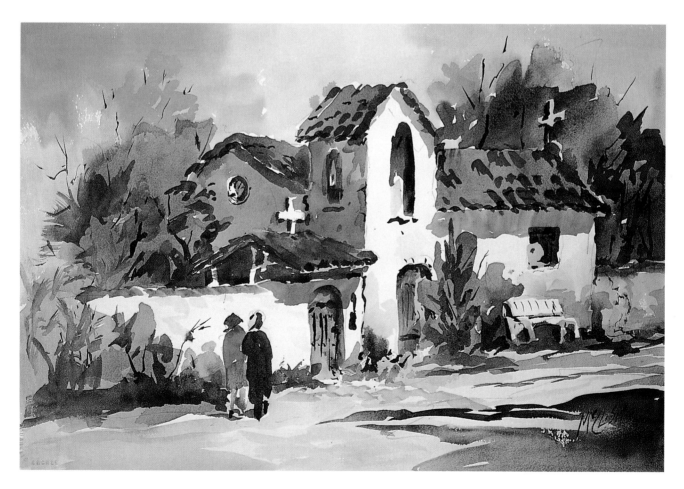

To see how lightening the value of the roof will affect the painting, appropriate white shapes are layered over the three roof areas, as can be seen in the detail, left. Next, the acetate is placed over the work and a light warm glaze applied over these white areas, to simulate red tiles in sunlight. The tree on the left of the painting is also enlarged since it was practically the same height as the building, as the original on the previous page shows.

Since nothing sparkles as excitingly as a white building in sunlight, there is a need to darken the value contrast elsewhere in the painting. Accordingly, a warm, burnt sienna glaze is placed over the road and gradated darker towards the edge of the painting. As mentioned earlier, all these changes are minor, but increase the readability and effectiveness of this work.

The Solution

Clarification of shapes through value alternation. Adding emphasis to the whites by gradation of other areas.

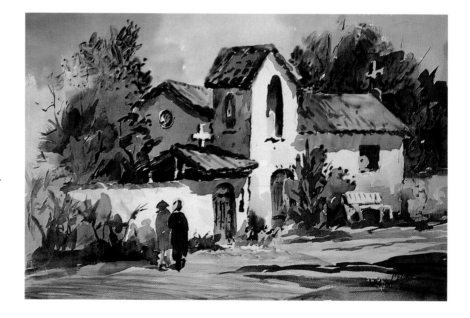

90

12
Adding Interest and Scale

On acetate, painting darker values over a light painting is simple and effective. As the previous page points out however, another procedure applies for the addition of white shapes. You could certainly use a tempera white on the acetate, but any modifying glaze over it would be difficult to handle. We prefer recreating the white paper by simply placing an appropriately cut-out shape directly on the painting to see how it works. Then, if the white paper addition needs to be modified, it is easy to glaze some tone over the acetate. We have many uncompleted paintings that lack a center of interest, and it is amazing how the addition of just a few snippets of white will create that much needed focal point.

Since roofs catch a lot of light, rectangular shapes and parallelograms are added to simulate distant roofs. These can be used over and over when working with the typical landscape. When dealing with a lake or coastal scene, a triangular snippet of white will create the illusion of a distant sail and often form a welcome interruption of an otherwise monotonously straight coastline.

For more complicated shapes that require some drawing before they are cut out, use a thinner paper that gives you a hint of what is underneath. Place it on top of the painting so the needed white shape can be drawn in direct proportion to the work. Keep shapes as simple as possible, as suggested by those on the right.

Having Fun With Snippets

The painting of our Intracoastal Waterway, on the next two pages, is really a completed painting by itself. Several white shapes were added just to demonstrate the effect they create. As you can see, these small additions really do form convincing focal points. In this case, pressure sensitive adhesive labels were used and very lightly placed on the painting. They can easily be removed once a decision is made which shapes to keep and which to discard or move to another location. Although you may not wish to make these changes, they do give you a good preview of the possibilities.

Just for fun, nine snippets of white were added to this painting. Can you find them all?

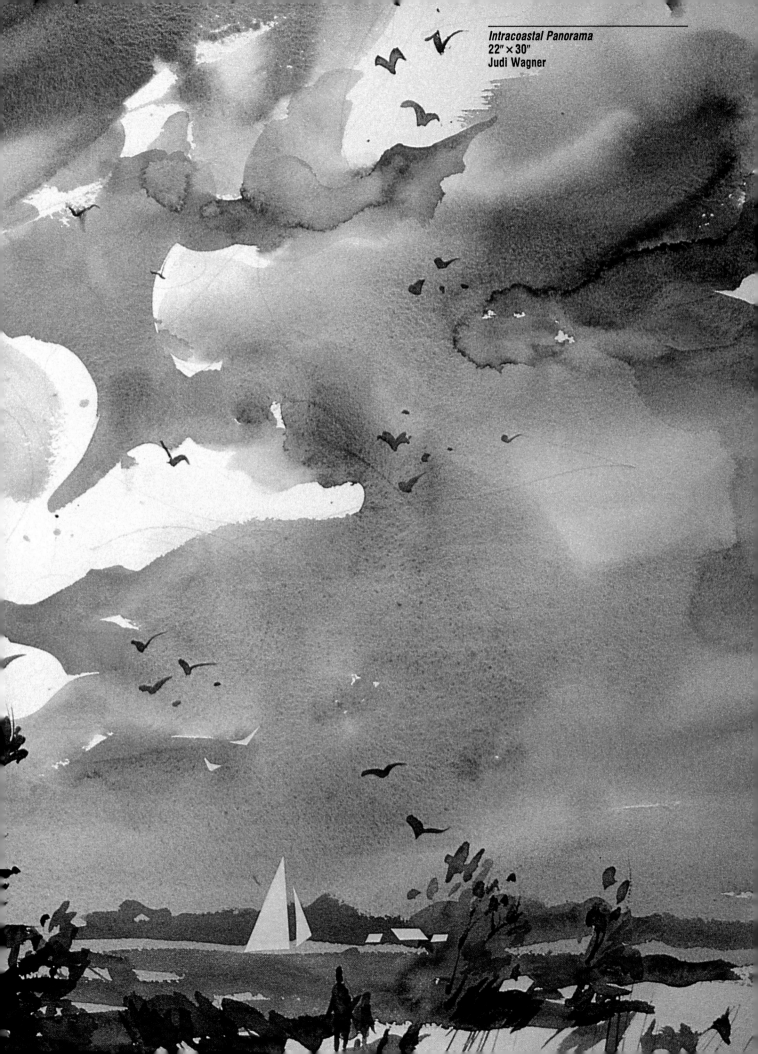

Intracoastal Panorama
22″ × 30″
Judi Wagner

Mesa Backdrop
15″ × 22″
Tony van Hasselt

Adding Scale to a Painting

The magic, grandeur and immense size of this mesa backdrop in northern New Mexico is difficult to express on the limited size of watercolor paper. Notice, however, the addition of the white roof shapes that not only create a center of interest but, at the same time, add scale to the painting.

Once shape and placement decisions are made, a light pencil line is traced around the white paper snippet, after which the snippet is discarded. Now the paint within the pencil lines must be removed to reclaim the white of the watercolor paper. This can be done in two ways: Small areas can be reclaimed with the delicate scraping of a single-edged razor blade, while larger areas are masked off and lifted with a sponge or bristle brush. In this case, pieces of pressure sensitive labels are used as masking material, as seen on page 95.

Next, a small bristle brush is moistened to gently loosen the paint from the paper. Once loosened, it is easily blotted with a tissue. As the larger roof shape in the lower right detail shows, the white of the paper is never fully recovered in this manner, but that is not as important as you may think, since pure white stands out too much anyway.

The Solution

As seen in the example at bottom right, adding a focal point increases the scale of the cliffs.

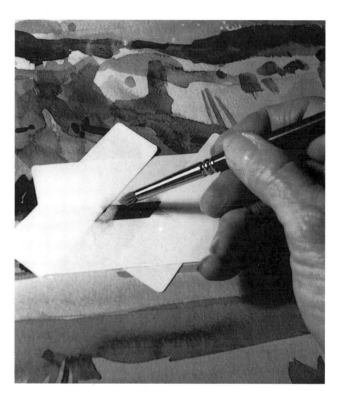

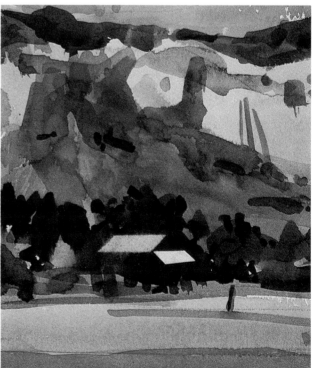

Other Ways to Add Scale

Scale can be achieved in several ways. In *Sunday Afternoon*, the lonely figure on the rocks takes the focal importance away from the distant trees and, in addition, gives scale to the rocks and distant island.

In *Virginia Reflections*, top right, the actual size of the pool is relatively small. On observing the painting back in the studio, we felt that a center of interest, a place for the eye to focus, was needed. A roof-shaped snippet of paper was placed in the upper right corner and seemed to be the best solution. The area was masked off and the paint removed as shown earlier. Finishing details were added, and although in actuality that house would have been no larger than a doghouse, it added just the right note to this painting.

Usually adding a figure or building can make the background more immense. The opposite is true in *Hidden Cove*. This painting started as a 15″ × 22″ half-sheet depiction of a small pile of rocks along a California beach. The actual size of the whole subject was perhaps six feet wide.

The unsatisfactory result tossed around the studio for quite a while, until some creative cropping eliminated badly painted areas and reduced the painting to its present size. A good focal point was not added until weeks later, when the thought occurred to us that the addition of a boat and some small figures could transform this six feet of California coast into some mysteriously private beach.

Sunday Afternoon
22″ × 30″
Judi Wagner

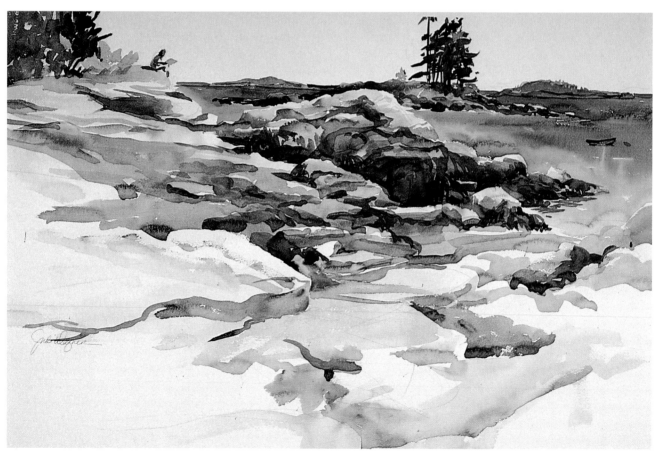

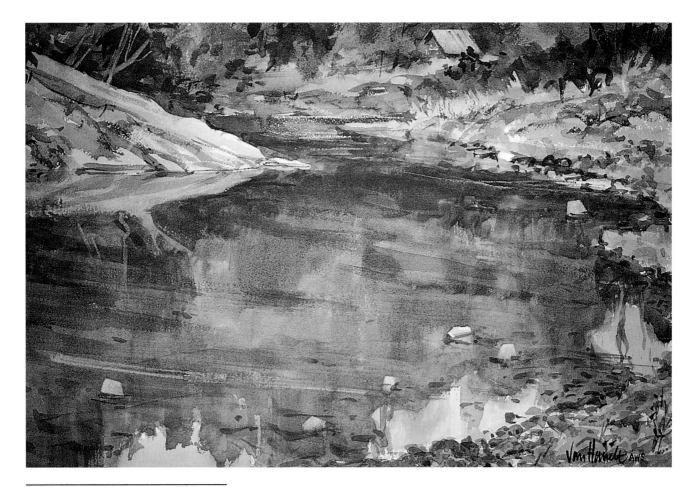

Virginia Reflections
15″ × 22″
Tony van Hasselt

Hidden Cove
9″ × 22″
Tony van Hasselt

13
Making Complicated Changes

This freshly stated painting has a pleasant feeling of sunlight and warmth. There is little "wrong" with it, but the two dark shapes in the center are basically square. As seen on page 27, such shapes are not as interesting as those that have light shapes piercing into them, causing an interlock between the light and dark shapes, similar to the pieces of a jigsaw puzzle.

These square shapes can be made more interesting by having something jut out of the shed and catch the full sunlight. Working on location will help you accumulate a rich repertoire of realistic shapes to use when correcting work. For instance, in this painting we initially came up with ropes hanging from the rafters. That idea was rejected since those shapes would not be massive enough and, since they would be hanging inside the shed, their value would still be dark. A sign jutting out and partially catching the light was another idea. Finally, a simple sawhorse with a

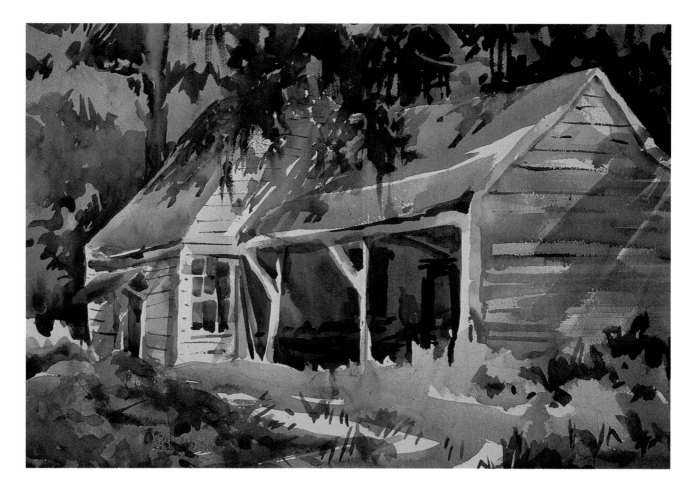

board leaning against it seemed the best solution.

As seen in the close-ups, the sawhorse is drawn on plain typing paper that was placed over the painting and later cut out with a small knife. This cutout was tried out in the center stall, but that idea was rejected since the sawhorse would draw too much attention to the exact center of the painting. Instead, the shape was moved to the end stall near the figure. As you can see, that shape really breaks up the dull square.

Placing the acetate on top of the work, light tones were added to the sawhorse to eliminate the stark white feeling of the paper, but the white on the board was retained to add punch. Some plausible cast shadows were added and the result was much more interesting, as can be seen in the new version. Let's see how to actually make those changes.

Making the Changes

With a rather complicated shape such as the sawhorse, it is too difficult to mask everything off exactly, as is done with simple roof shapes. In a case such as this, it is best to remove the paint from a larger area and, once the paper is dry again, reshape the lights by repainting the surrounding dark areas.

As can be seen in the top left close-up on page 100, pieces of paper are masked around the edge of the shape. The paint is first removed with a cellulose sponge and then with a stiff bristle brush, while the area is constantly cleaned with tissues.

After the paper is thoroughly dry, the sawhorse cutout is placed within the masked-off area and the holes are filled in with a small, round brush and some dark paint mixture to approximate the exist-

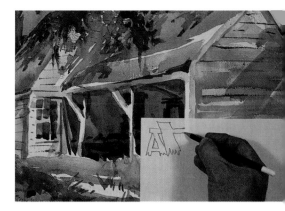

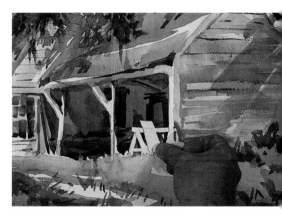

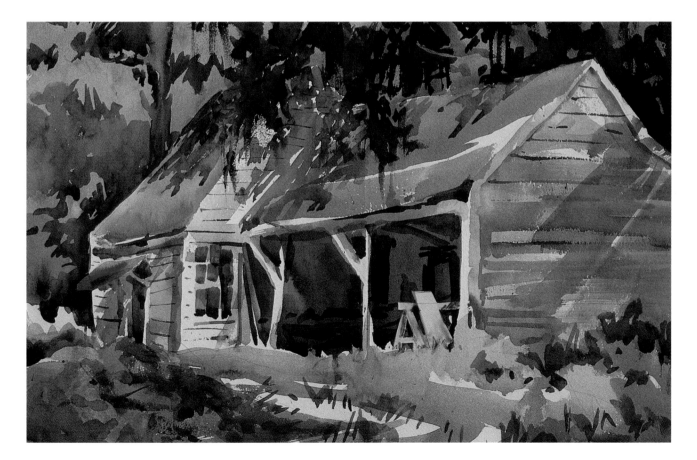

ing background, as can be seen in the two close-ups, below right.

After removing the masking pieces, it is time for the finishing touches, which make it all believable. With a single-edged razor blade, highlights are scratched along the top edges of the saw-horse as well as on the board. Where the board is in sunlight, the area is scratched back to white paper. The cast shadows caused by the shed are painted over the end of the sawhorse as well as on part of the board. Smaller cast shadows are added where they occur and, by indicating some grass in the foreground, the whole change is blended into the painting so it will not stand out as a later addition.

After reading Adding Actors to the Stage on page 114, you can place the acetate over this painting and add a dark figure in front of the sunny end of the shed. It will really add the finishing touch.

The Solution

Changing the shadow shape creates a more interesting area on which to focus attention.

The Potting Shed
15″ × 22″
Judi Wagner

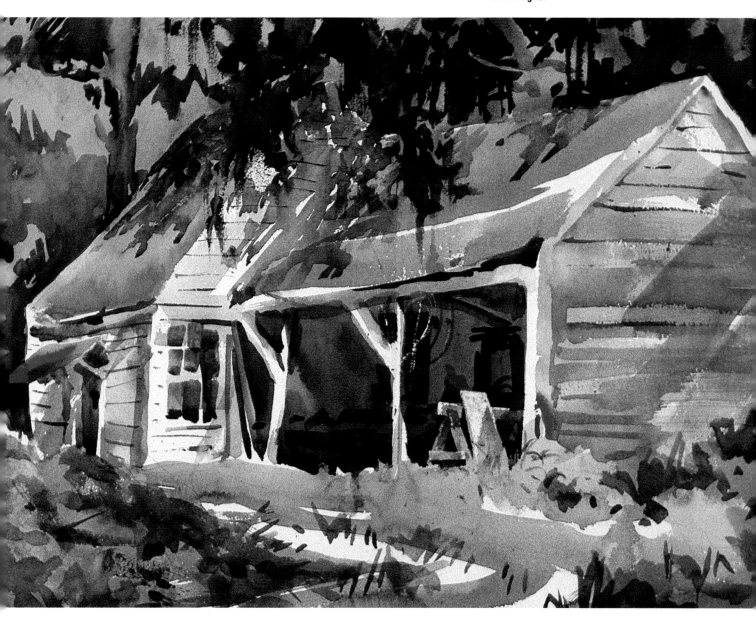

14
Adding Punch to Your Paintings

Using Separators

A separator is a dark shape placed between two areas that are similar in value. For instance, imagine the left two buildings without the existence of the dark tree. This tree shape is not only an excellent example of the power of a separator, but in addition, the *shape* of the separator can help to explain another shape better, as is seen in the repainted tower area in the lower version.

Another important benefit of the separator is that it can add emphasis to an area. For instance, compare *High and Dry*, below, with the photograph of the actual scene. In the on-location painting, the shadow of the right building was lengthened to reduce the white space, which cuts a flag-like

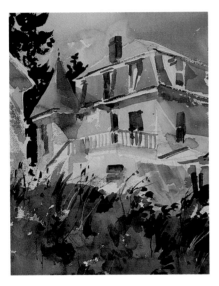

path through the scene. Not satisfied with the result, the dark trees were added later in the studio to reduce the amount of white space and to add the extra dark value needed in the painting.

Separator Improvements

This New England farm subject is an obviously unfinished painting. When an artist is working out-

High and Dry
15″ × 22″
Tony van Hasselt

The Solution

Strong value contrast adds interest at the focal point.

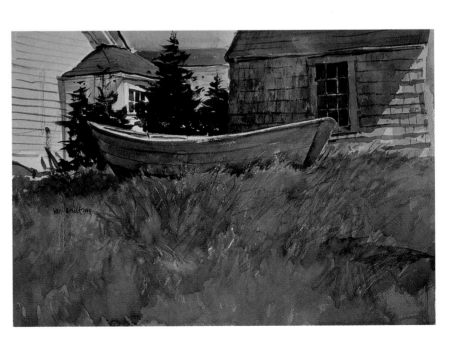

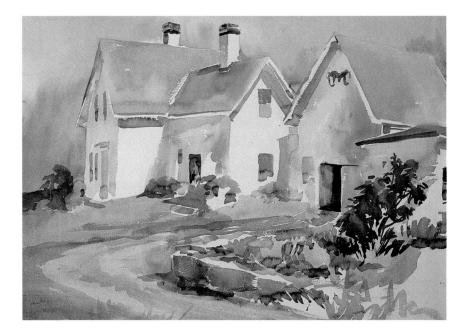

doors, there are always reasons why this happens. Perhaps it started raining, or the cows were loose. Who knows. The unfinished result was pulled out and the separator darks were added on an acetate overlay to dramatically set off the building shapes against the sky. In addition, gradated washes were added to two of the roof areas to make their value distinctly different from the value of the house. Can you find the areas? Additional gradation could have been applied to the foreground, but the emphasis of this demonstration is to show you the power of the separators.

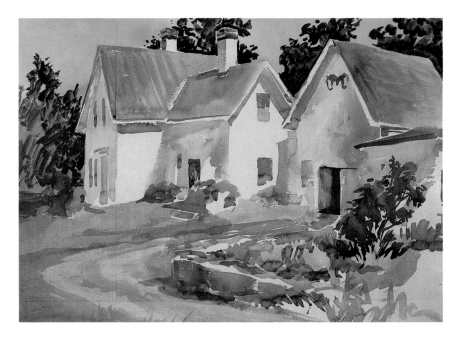

The Solution

The addition of a dark value separator clarifies the roof shapes.

Weaving Ribbons Through a Painting

This moody scene is another one of those uncompleted paintings started outside and interrupted by rain, the enemy of all outdoor watercolorists. Most values were in place and only the darkest one needed to be added.

On subject matter such as this, we look for the possibility of weaving a ribbon of dark through the whole painting, as can be seen in the photograph of the acetate overlay. Placing this overlay over the work adds the punch and strength needed to complete the painting. This is also a good example of the benefits derived from doing the tree exercise on page 35.

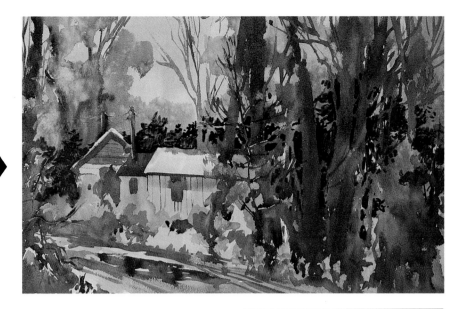

In our section on dominance, *Dancing Rhythms*, shown on page 48, was an example of curvilinear shape dominance with the accent of a straight line missing. Here, this straight line was added on the acetate as a dark ribbon of ocean, woven through the painting. When you compare this second version with the original, note how the addition forms a stabilizing accent in the painting.

The Solution

The addition of a dark value weaving itself through the scene adds the dark punch needed to complete this painting.

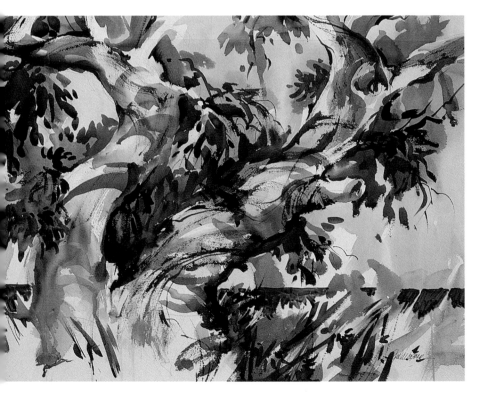

The Solution

The addition of a straight accent makes the curvilinear shapes truly dominant.

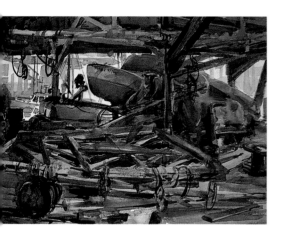

15
Cropping Successfully

The Solution

By cropping, the shape of the boat is made clear.

Have you ever started out painting a full sheet and ended up framing your work as a quarter sheet? You are not alone. Naturally, with proper planning the incidence of this happening is dramatically reduced, but it is better to save and feel good about even a small piece of your painting than to tear the whole thing up in disgust. Creative cropping can enhance and strengthen the design, zeroing in on what we really *wanted* to feature and eliminating unnecessary extras.

For instance, *Rainy Day Subject*, on page 30, was originally cited as having some shape problems. Rather than fixing and repainting it, cropping was used as an alternative to make this into the much stronger painting reproduced below. Take an old mat, cut it into two L-shaped sections and move them around on your work to find the best solutions. Who knows, you may even find two or three jewels hiding in that discarded work.

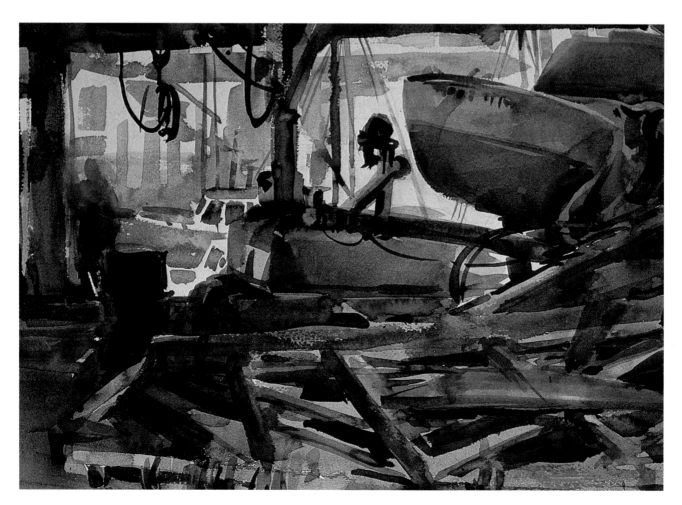

When All Else Fails . . .

The full, 15″ × 22″ vignette version of *The Inspection*, above, is another one of those paintings that, although a good example of a vignette, had a dominance problem. The white space was challenging the subject matter for attention. The cropped version below, although no longer successful as a vignette example, zeroes in more directly on the subject and becomes a stronger painting.

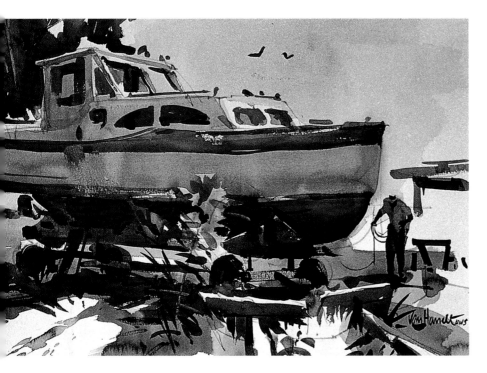

The Inspection
11½″ × 18″
Tony van Hasselt
Collection of Mr. and Mrs. Howard Kahn

The Solution

By reducing the white space around the subject, dominance is restored.

16
Replanning and Lighting Your Subject

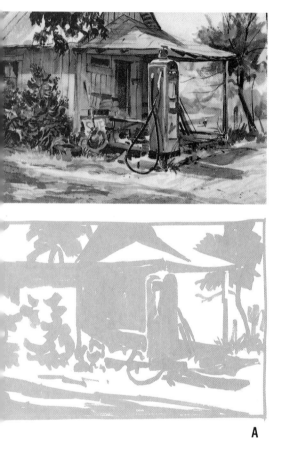

A

While preparing to paint the subject at left on location, this artist *knew* the drawing had to be correct, but "that's the way it was" can lead to confusion and prompt the question, "Why is the gas pump holding up the roof?" As you can see, the crucial importance of an identifying silhouette shape was ignored. The problem already existed in pattern sketch A, which is an *early warning system* for problems ahead. Unfortunately, there is no simple way to fix this painting, so here is a chance to do some replanning.

Beginning with several pattern sketch ideas, the pump was moved to different locations to clearly display its telltale silhouette, light against dark. Although version B does this, the pump, with its most intense color, would be right in the center of the painting. Moving the pump to a better focal point, as was done in C and D, is a solution worthy of a new try. Although either sketch will do, the demonstration will be based on sketch D.

B

C

D

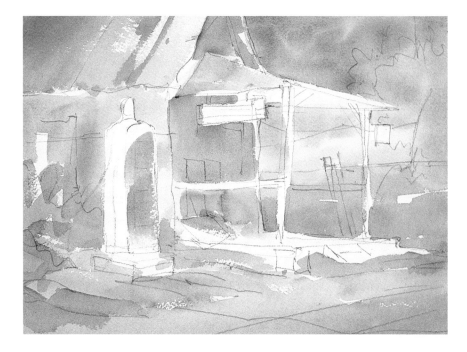

Step 1.

Our procedure is to work from large areas to smaller ones, from light values to dark ones, and from soft edges to hard ones. Consequently, after the drawing was lightly stated, most of the painting was covered with light washes of the approximate color and value. It is important at this stage to think of "nice" colors, rather than grayed-down versions. Make your colors more colorful. You can always neutralize them at a later stage. Note that some areas are kept white and that a soft-edged mingling of colors takes place. Do not stay rigidly between the lines unless it is absolutely necessary.

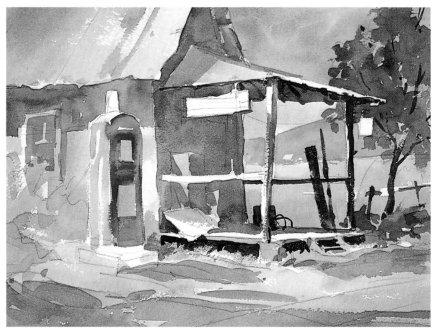

Step 2.

At this stage, the shapes decided on in the pattern sketch are glazed over the results of the first stage. Actually, the first stage denotes the white areas in the pattern sketch, while the building of the painting takes place at this phase, when the darker values are being introduced. This phase is also the harder-edged one. Color mingling may take place *within* a glaze, but the paper is dry and, therefore, the edges are sharp. Note that some darker values are being added.

Step 3.

Additional applications of darker values add the final touches and punch. In this new version, better shape identification and better color dominance was the goal, since the original had some very sick greens in it. One good reason to save unsuccessful attempts, is to try again, when more knowledge and experience have been gained.

The Solution

Better planning clarified the shapes in this subject.

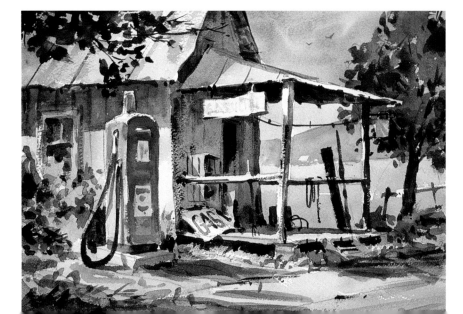

This area seems too dark and solid to be the most distant plane in this setting. It moves forward and therefore destroys depth.

To gain depth, details should be kept in the foreground and reduced in background areas. Consequently, these windows can be eliminated, since they are located so close to the main subject.

Be aware of the size relationship of doors and windows. This door seems too small when compared to the windows.

Value alternation could change this brace to a light value against the dark background.

Keep all braces at the same angle for uniformity. This one ends at a bad place, coinciding with the edge of the building.

Here is an excellent example of something overlapping at a bad place. The viewer *needs* to see the front of the boat. Moving the brace to a better spot to keep the shape clear is a good solution.

The side of the boat is at a different angle from the upper structure, so something different could happen there. Such plane differences can be explained with the help of a different value. Remember: When there is a plane change, there generally is a value change.

This whole area is too dark. It needs value alternation to at least hint at what is going on. When a dark photo does not supply this, more research is needed. Take close-ups and draw out details for further reference.

Gradating these roof areas from a light to a dark against the sky will make them more readable.

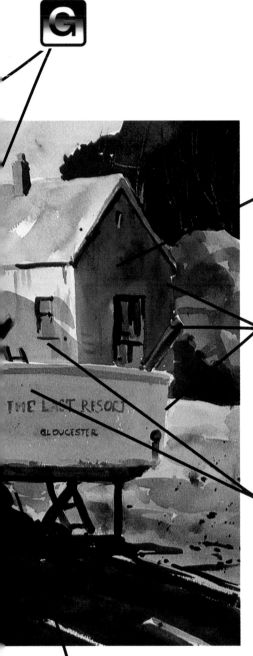

This shadow side of the house seems too colorful, especially since the blue is not repeated elsewhere in the painting.

Here are three tangents that need to be changed. The house should not end where the end of the boat is located. The angled boat brace also ends along that same line.

The value and temperature of the stern shadow is identical to the shadow on the house. An opportunity is missed to alternate values and play a warm against a cool.

One of the identifying shapes of a boat is its propeller, so feature it, whether it is there or not.

Most watercolors we see are timidly executed and the student has to be encouraged to use more paint and darker values. This work, on the other hand, is so strongly stated that caution should be advised with the darks. The *choice* of subject matter is absolutely fantastic. However, thorough examination of problem areas point to the need to replan this painting. We don't know if

this was painted on location or from a slide, and it does not make any difference. Just realize when working from slides that they have to give clear information in dark areas, such as under the boat. Care should also be taken not to copy the slide verbatim. Always ask: Will this shape or value be understood by the viewer?

A line drawing of this subject was made and, with a black and gray felt-tip marker on tracing paper, several checkerboard patterns were explored, much as you were asked to do with the barn on page 23. In the top two sketches the light source suggested in the original was followed, while in the lower two we tried other approaches. The benefit of such simplification is that one really learns to place a light shape against a dark one. *If you use limited values and colors, you cannot be side-tracked by anything else.*

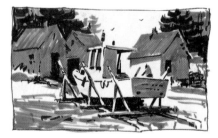

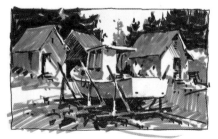

As the sketches on the previous page point out, the planning starts with them. For instance, guided by the light source on the original, as well as some of the sketches, the version, below left, was painted to correct some of the obvious problems with the original painting. The temperature dominance is warm, the accent cool. Colors are balanced, shapes are clear, and the subject is the boat.

The Artist as Lighting Director

Taking work back into the studio gives you a good chance to reevaluate a scene. Imagine the painting to be a stage for which you are the lighting director. Where will the star be located? Where should the viewer's eye be directed? That type of approach is nearly impossible to pursue outside, but so much fun when things can be planned out quietly in the studio.

For instance, what would happen if the boat were placed in shadow and the buildings beyond were bathed in the spotlight? For a spotlight to be effective, it helps to turn off the lights everywhere else. In a painting, this means that tones and values are relatively dark everywhere except in the spotlighted area and perhaps some secondary light area. An example of this is seen below right. A secondary balancing light can be found on the stern of the boat.

Once the viewer's attention is where it should be, it can be entertained with the most vivid colors and detail. Here in the spotlight, the actors should be placed. All other areas have only a supporting role. To prevent them from stealing the viewer's attention away, those areas have to be subdued.

To demonstrate this spotlight idea, see the step-by-step sequence of the final version on page 113.

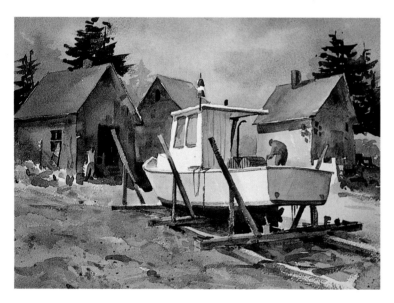

In this version the boat is spotlighted. The surrounding area is relatively dark.

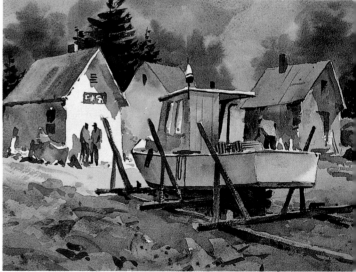

In this version the spotlight falls on the building beyond the boat. Notice that the "actors" are placed in the spotlight.

Step 1.

The same drawing used in the other versions is lightly traced onto the paper. After the placement of the spotlight had been decided, a gradated blue-gray wash was placed over the whole area, radiating towards the focal point. This treatment created an effect just like a spotlight would create.

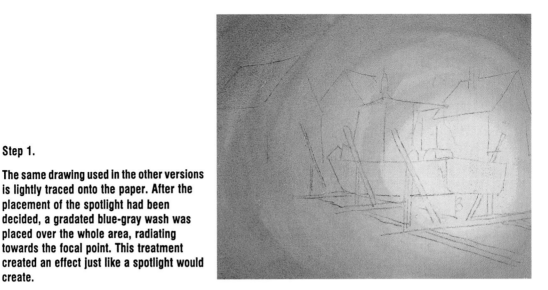

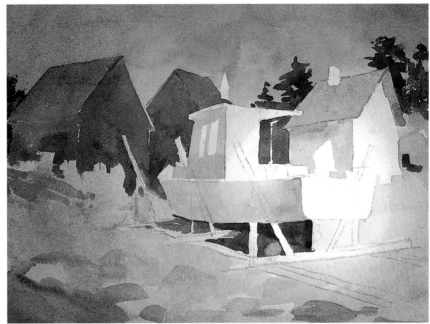

Step 2.

After the initial wash is completely dry, local colors and values are glazed over the painting in the normal manner, *as if* it were white paper. Care is taken to keep gradation towards the spotlighted area.

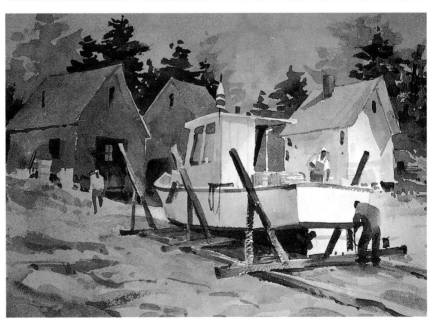

Step 3.

The final darks and finishing details are added and a small, balancing light is lifted out of the area in front of the boat. Again, figures are placed within the spotlighted area.

17
Adding Actors to the Stage

A viewer identifies with figures in a painting. The eye seems to be drawn directly to them if they appear in a landscape. Many watercolorists are afraid to add figures to their work because in the past, some nice paintings were messed up by the addition of unsuccessful stick figures. Realizing we don't know enough about anatomy creates insecurity and the fear to tackle those needed figures.

But wait. Remember we are *landscape* painters and the figure is only an *incidental* part of that landscape. It has to be painted well enough to be convincing, but these are not illustrations nor portrait or figure studies. So relax. We will show you how it is done and you will know whether that incidental figure looks right or not. By using the acetate, you can try it out before committing yourself on the actual work.

Worrying about what type of figure to paint and what action it will be involved in can be very frustrating. We have another approach. We simply make a few marks and let the marks *suggest* what the figure will be doing. We don't say, "This figure *will* be doing such and such." Our approach is to say, "This shape *makes me think* of a figure doing so and so." That is a basic difference in attitude and makes painting that figure much more fun.

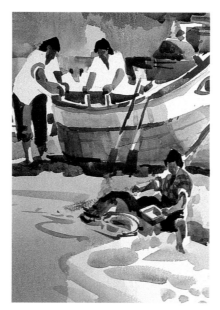

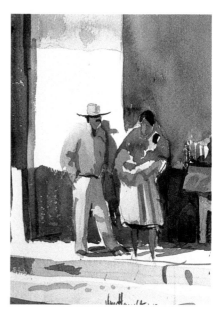

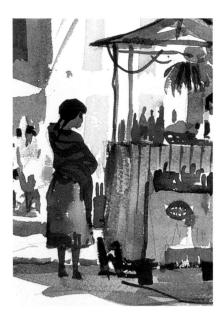

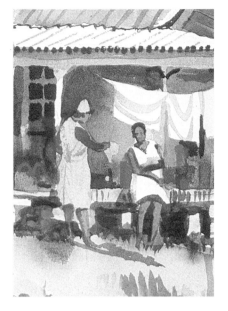

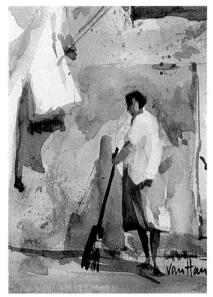

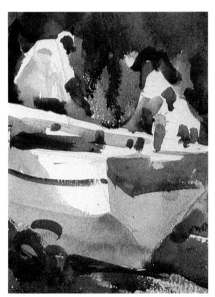

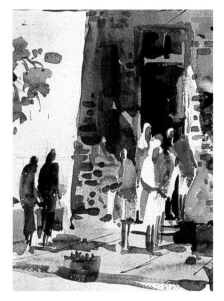

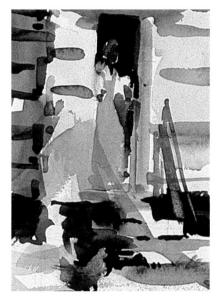

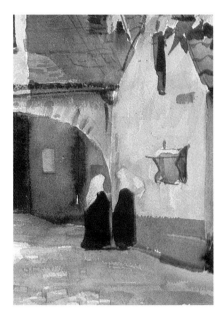

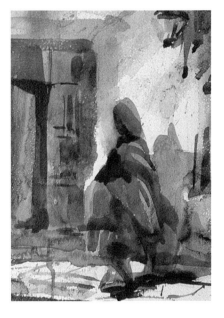

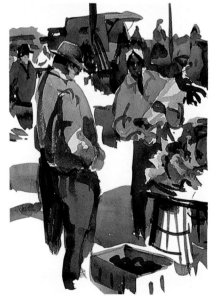

Fun With Figures

Let's practice creating a few figures before going to the actual watercolor paper. Start off by using drawing paper with a smooth surface and an no. 8 or no. 10 round brush.

Step 1. As the brush diagram suggests, use the side, not the tip, of the brush to obtain the strokes displayed at the top of these pages. Make your strokes about this same size, color and width. Make the mark with *one* stroke. Don't worry about making it "perfect." You are doing the upper torso of the figure. Give it some bulk and angle the stroke a little. This will avoid the stick figure that stands ramrod straight.

Step 2. Next, gravity comes into play. That figure should not look as if it will topple over, so place the pant legs where they will balance the weight of the torso. Use the vertical edge of the paper as a comparison guide. These marks are still made with the side of the brush, but a bit closer to the point. Extend those legs longer than you feel they should be. With the ladies, add a skirt shape and use burnt sienna for the legs. Just taper them to a point. Don't worry about feet.

Legs do not necessarily have to be connected to the torso. The third figure from the left could be wearing white shorts for instance. In the sixth figure, some blue strokes were added to suggest shadow areas on a white skirt. Some torso color was also lifted from that figure to allow the head to be inserted. Note also that figures three and four and seven and eight are placed closer together. It is better to have figures overlap than to stand isolated.

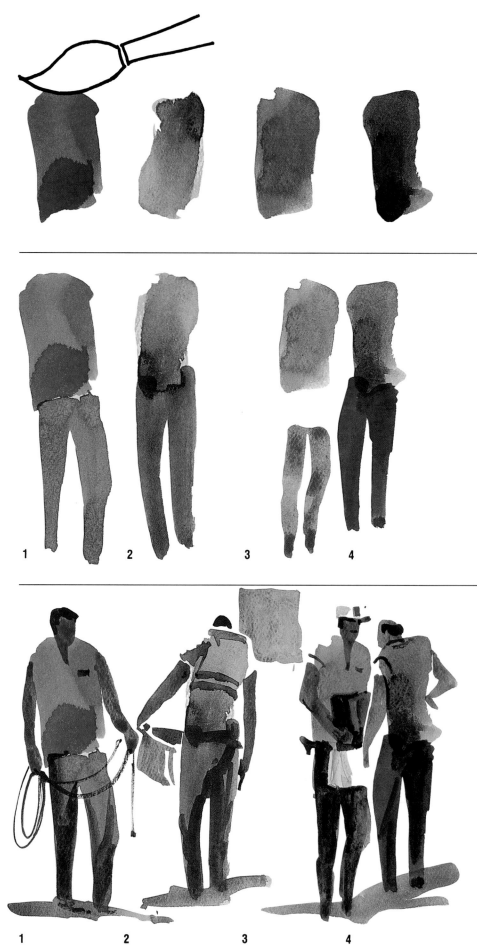

1 2 3 4

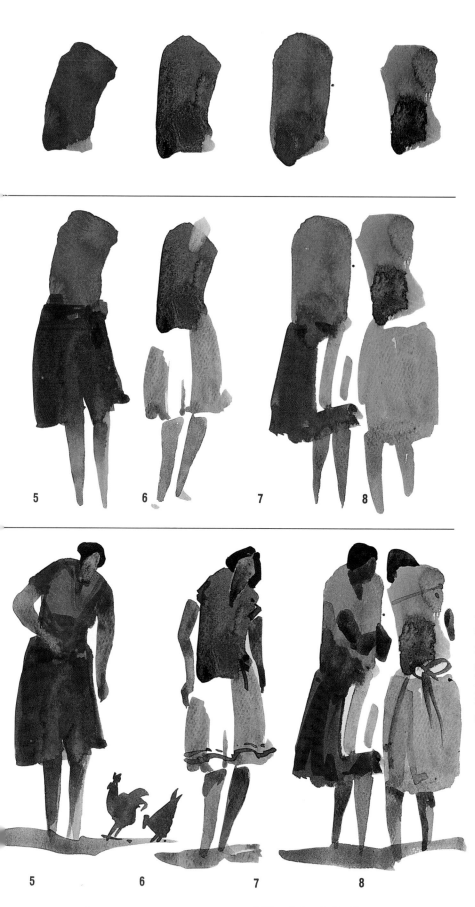

5 6 7 8

5 6 7 8

Step 3. Now it is time to paint the head and arms, again using burnt sienna. Make the head much smaller than you think it should be. Avoid placing it dead center on the torso. Place it wherever the existing marks *suggest* it should be placed. Does the mark look like the figure is coming toward you or is its back to you? The first one seems to face us, so a comma-like head is placed on the torso, with the tail of the comma suggesting a neck opening. The second figure suggests someone seen from the back; only a small indication of a head is needed since most of it is hidden behind the shoulders. Other heads were added in the same manner. Use the tip of the brush for the arm and leg marks. Place those arms where they feel right. Experiment to see what happens, and remember, you don't need to show every arm.

Step 4. Some darker values are used to add hair, some stripes on the clothing, and whatever props complete the setting. With the first guy, a rope is added. On the second one, the placement of his arms suggests that he is carrying something. Note that those shorts on the third person changed into a work apron and he is carrying some bag or box. The first female figure is feeding some chickens and so on. Dream and have fun. Note that feet simply disappear into the shadows underneath each figure.

Trying It Out

After trying several pages of figures, you are ready to get out the acetate and add some figures to the subject below. Just for fun, we added two colorfully dressed ladies against the adobe wall since this scene was originally painted in New Mexico. Are they gossiping about those artists who came to paint their town? After your figures are painted on the acetate, move it around to select the best spot for them. Once that decision is made, you can paint those figures right into the scene, using the acetate version as a guide.

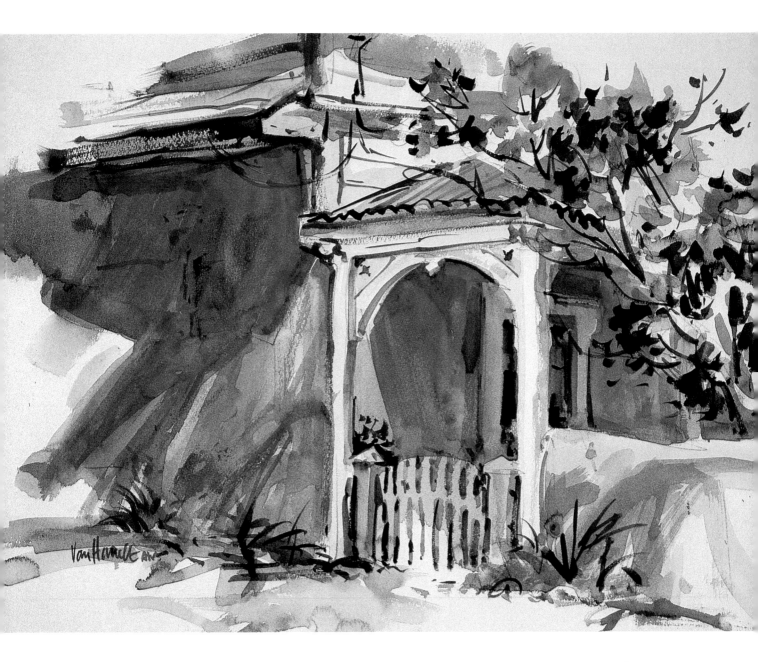

Some General Thoughts on Figures

Here are a few general guidelines and thoughts for adding the incidental figures to your landscape:

- Avoid action figures such as runners and jumpers. The most successful additions are those figures who just walk, converse, or stoop to do something.

- Remember the alternation symbol. Place the light figure in the dark doorway and the dark figure in the sunny spot.

- Relate the size of the figure to its surroundings, such as doors and windows.

- Generally, the color used on clothing is much brighter than other areas in the landscape.

- Clothing does not *have* to be colored. Some folks wear white.

- Avoid rendering features unless you are doing an illustration.

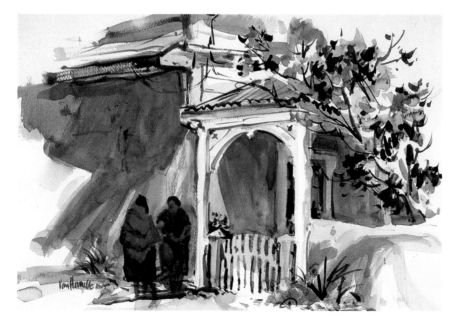

The Solution

Figures add a focal point to this scene.

18
Planning and Shaping the Light Figures

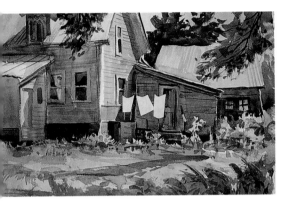

As seen in the previous experiment, adding dark figures over light backgrounds is easy to do on acetate. Adding *light* figures over dark areas is a bit more complicated. Suggested changes in this backyard subject, below, will show how it is done. The scene is not unlike an empty stage set. Everything is in place, but the actors have not as yet appeared. How can this subject be enlivened?

Breaking up the lean-to shadow with laundry shapes, as seen in the smaller version, at left, is one way to bring light into that dark area, but it creates another problem—an unfortunate focal point right at the center of the painting. A figure added at a bet-

ter place will pull the eye away from the painting's center. The laundry will remain in the center of the work, but the figure becomes of first importance; the laundry is cast in a "supporting artist" role.

Since the background is dark, a light figure must be added for contrast. Just as with earlier examples of light additions, white paper is used. This time a tissue was roughly torn and crumpled in the approximate shape of the figure and placed underneath the acetate, as can be seen in detail 1 on page 121. We refer to these crumpled pieces of tissue as *ghosts*. At this stage of the addition we are not interested in the exact shape of the figure, but only

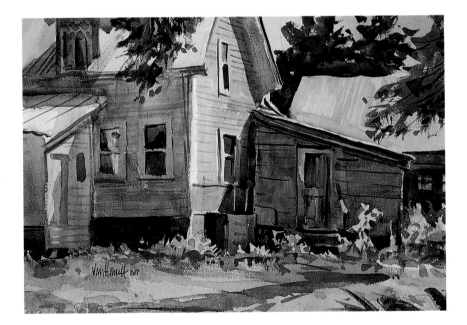

where it is placed, so a general ghost shape will do.

In the detail 2 close-up, the silhouette of our ghost shape is changed into the needed figure. Since it is quite a wide shape, two people could actually be made out of it by overlapping the figures. It certainly seems reasonable that a neighbor came over to chat with the lady of the house. The approximate background color is painted on the acetate by cutting into our ghost shape at the shoulders, which creates the head. Some more adjusting of the silhouette takes place at the waist, but note that the feet are practically nonexistent.

In detail 3, the white shape is broken up with blue shadows and the face, hair, and arm colors are added. Finally, by placing a piece of paper underneath the acetate, detail 4, you can see what has happened to shape our ghost into the two figures. The resulting changes, below, are just on the acetate. The actual painting has not been touched. Therefore, should you have a change of mind and find this is not the right finishing touch, another approach can be explored. If you are satisfied with the effect, the general figure area has to be masked and the paint removed as was done with the sawhorse on page 99. You can then reshape the figure by repainting the background in the same manner demonstrated for the sawhorse.

The Solution

The addition of figures enlivens a dark area and adds a focal point. (These changes are just on the acetate.)

1.

A tissue was torn and crumpled into the shape of a figure and placed under the acetate.

2.

The silhouette of the "ghost shape" is changed into the desired figure.

3.

The white shape is broken up with color, still painting on the acetate.

4.

By placing white paper under the acetate, you can see what has happened.

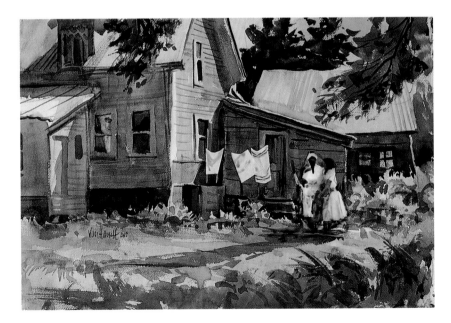

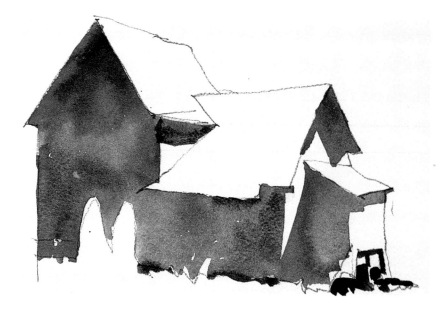

and save those precious whites. The more you paint, and the more you get into trouble — the more you learn to think ahead and keep your white options open for later development. And needless to say, the early warning system of the pattern sketch alerts you to just *where* to leave those whites.

La Iglesia offers an interesting twist to the saving of white spaces. This painting was started on a Sunday morning in a sleepy Mexican village. The subject was selected because of the interesting textures and shadow play on the church entrance. Those dull and dark rectangular openings *had* to be broken up and made more interesting by adding some figures in front of them. Being sensitive to the possible reaction of real-life bystanders, however, undeveloped white spaces were left there, as seen below, and the painting was finished back in the studio.

As seen in the close-ups on page 123, the white shapes were first broken up with some blue washes, signifying white clothing in shadow. Since the shadow of a nonexistent figure had already

Keep Your Options Open

On location, when faced with a subject that includes a large dark area, it is a good idea to anticipate the later addition of some light figures by leaving ghost-like shapes, as shown above. These shapes can easily be modified into figures by reshaping the background a bit and adding convincing details as seen in the close-ups on the left.

In an opaque medium, the white figures could just be added on top of the dark paint. In watercolor, you have to think ahead

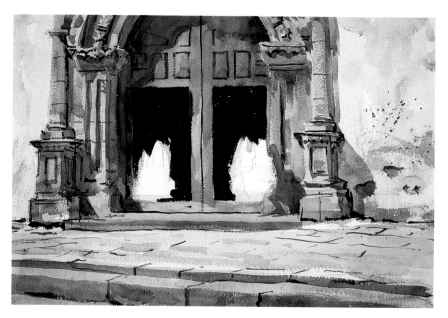

been established at the right entrance, her darker skirt was added at the same time. Some lighter areas were lifted out of the very dark interior to relieve its heavy feeling.

Next, faces, hands, and color accents were added and more figures were lifted out of the dark interior color. Still faced with the very definite separation caused by the two door openings, those dark shapes were linked together by adding the lady in black in front of the church.

Those finishing details looked good, but as the original version shows, everything was quite centered. The L-shaped mats solved that problem by eliminating most of the right side of the painting. Too bad, but the result that is pictured below places the grouping of figures at the best spot in the painting.

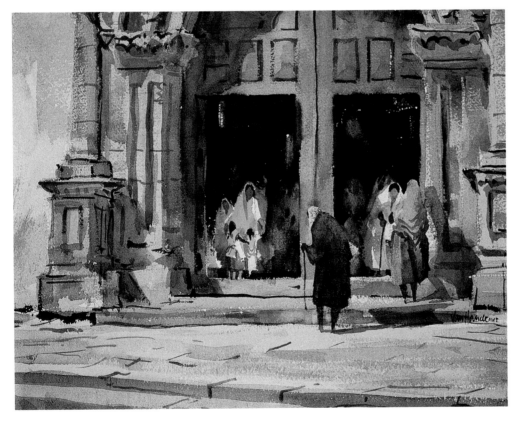

La Iglesia
12″ × 16″
Tony van Hasselt

Shenandoah Fall
15" × 22"
Tony van Hasselt

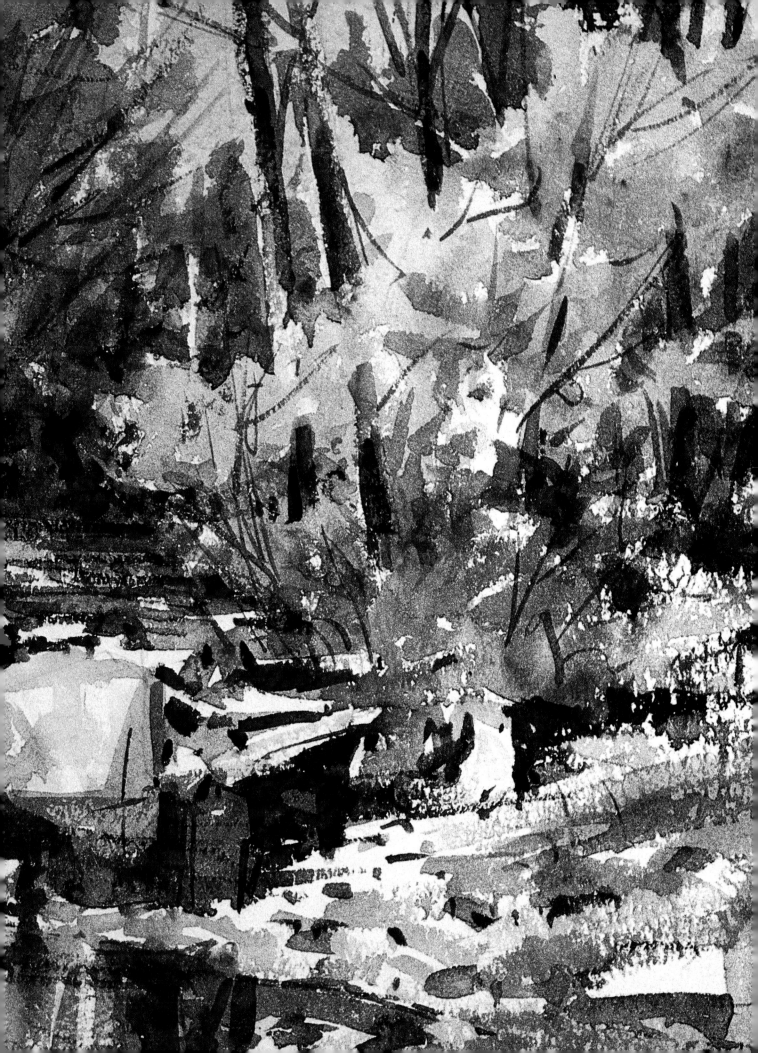

19

Finding Hidden Figures in Your Work

Detail from *Shenandoah Fall.*

The painting on the previous two pages, done on location in Virginia, is an excellent example of having a figure in your painting without even being aware of its existence. Not until this chapter was in the planning stage was it discovered that a lady *could* be sitting at the edge of that stream, shown at left. The hair and arm were added on the acetate, plus a dot of bright color for the skirt. What could she be doing? Painting of course, as the sliver of white paper and easel suggest.

It is simply amazing how often a figure can be discovered in existing work. You need to look for those bulky torso shapes practiced on pages 116 and 117. Or what about that spot of white? Could a few additions turn it into a figure? Is it located at a good spot or is it too close to the center of the work?

You're really looking for some shape that gives just a *hint*. Some shape that, with a few additions, turns that hint into a believable figure. It may be fun just to go through a stack of work, hunting for hidden figures and then coaxing them into existence. As you see, several more figures were found in *our* work.

This painting has some wonderful untouched white shapes to choose from. The one in the best spot was chosen and face and hands were painted. When those were dry, the hair was added for the finishing touch.

That dark spot in the window area gives the hint that it could be a head. Near it is a mark that looks like apron strings. This *possible* figure is not located in the best place in the painting, but it's good practice anyway. The face and arms of the man were lifted out of the dark shirt. Pants and a railing were added and very little was needed to bring the female figure out.

Here is a section of an old painting that never made it to the finals. What those white areas were intended to be is long forgotten, but look what happened when those head shapes were lifted out. After the paper was dry, the hat was scratched out. Some arms were added, as well as the dark values of the skirt and pants, to make this a believable couple.

Since this painting was done on a Southern plantation, that strange gray spot next to the window hinted at being some servant carrying a basket on his head. Local color was applied to that spot, and arms and legs were added. By eliminating the background stripes and adding some shading to the shorts, another believable figure was created.

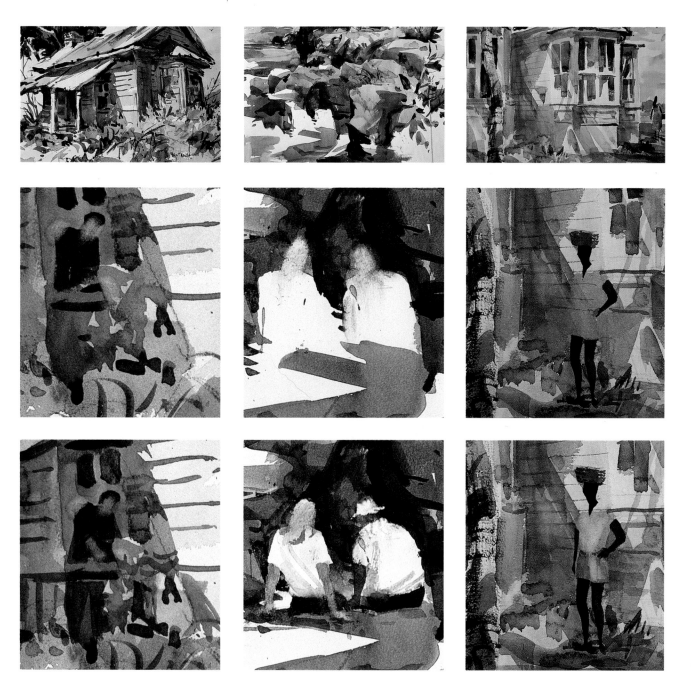

Take another look at *Dancing Rhythms* on page 48 and find the close-up area shown at left. Those spots have great figure potential. We couldn't resist the temptation to develop them, at least on the acetate. And can you believe the lucky location of that white spot that turned into the drawing pad? Adding the fence is another way to introduce the accent of a straight line in this dominantly curvilinear painting.

The paintings on these two pages are good examples of two different views toward introducing the figure. In *Dancing Rhythms*, the figures are prominently displayed. They become a storytelling part of the painting. In *The Boat Yard*, figures are virtually hidden from view. They are there, but do not become the subject of the painting. That powerful boat shape is still the dominant feature. The figure on the ground is purposely kept dark against dark so as not to attract too much attention. It does, however, give a sense of scale in comparison to the boat. You must decide which is the best way to handle the figure. It depends on the need of each painting.

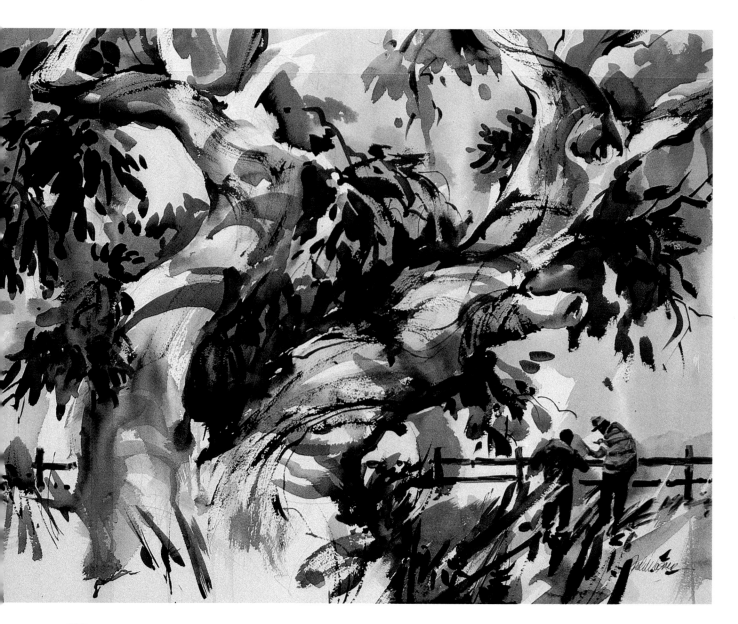

In Conclusion

We hope you have had as much fun reading this book as we had putting it together. As you have seen, it *is* possible to fix a watercolor, and our acetate method gives the needed assurance that those planned changes will indeed turn that so-so effort into a credible painting.

Much painting expertise is gained through what is learned *and remembered* from solving problems. So don't look at those unlucky attempts as mistakes or failures. If trying to fix them or cropping doesn't work, consider those efforts stepping-stones toward future success. Save them to look back on at some future date. You may even wish to try to repaint a few.

Looking at our efforts, we think Henry Van Dyke put everything in proper perspective with the following:

"The woods would be very silent if no birds sang there except those that sang best."

Good luck and much success with all of *your* continuing efforts to fix and improve your watercolors.

The Boat Yard
22″ × 30″
Judi Wagner

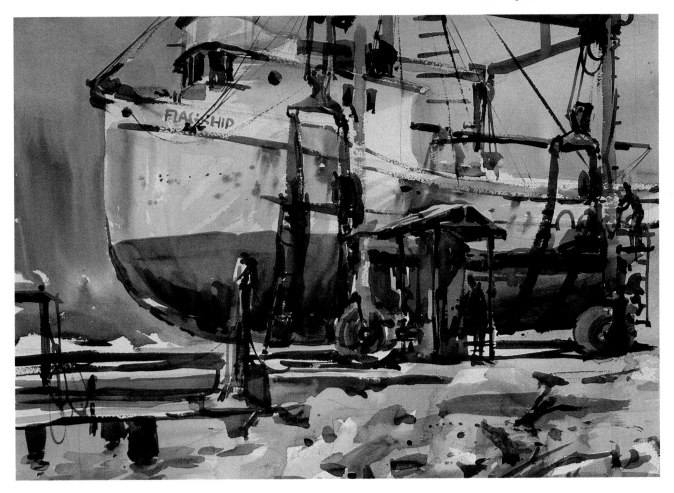

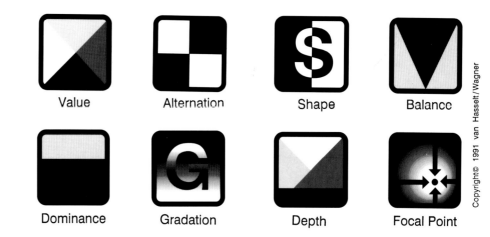

Value Alternation Shape Balance

Dominance Gradation Depth Focal Point

How to Use These Symbols

We hope that these building blocks of picture-making will help you *avoid* problems before they develop. These visual symbols were designed to remind you, the visual artist, of these foundation principles. They will keep you centered on that road to more successful work. Study these symbols regularly and review their different aspects so that they — at a glance — remind you of what to do during the painting process.

Make photocopies of the visual checklist above. Keep one in your painting kit, glue one in each new sketchbook, and tack one to your easel, so you will be constantly aware of these principles that create successful work. For those of you who wish to share these symbols with your students, an educational kit is available. For details, write to: Artnership, P.O. Box 1418, Sarasota FL 34230.

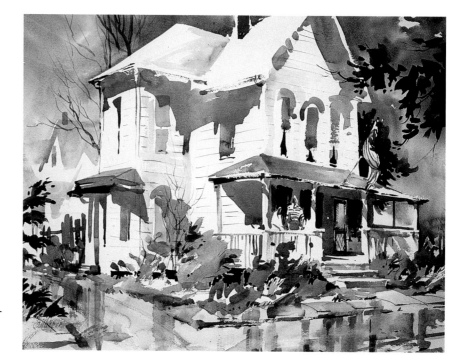

After the Rain
22″ × 30″
Judi Wagner

INDEX

A

Accent
 defined, 10
 directing eye with, 73
 straight, addition of, 105
Acetate. *See* Wet-media acetate
Adobe Abode, vi-vii, 39
After the Rain, iv-v, 67, 130
Air, challenge of painting, 69
Alternation
 concept of, 16-18
 to restructure painting, 21
 See also Checkerboard, concept of
Analogous gradation, 58
Artist
 as lighting director, 112-113
 attitude of, 87
Atmospheric perspective, 60
Australian Antiques, 40

B

Balance
 defined, 36
 in preliminary sketch, 38
Battenkil Barn, 38
Behind the Inn, 60-61
Beyond the Village, 72
Blustery Day, 10
Boat Yard, The, 128-129
Bridge, The, 65
Brunswick Docks, 31

C

Candy Lady's House, The, 61
Cape Neddick, 77
Carmel Mission, 47
Cathedral Overlook, 66
Cattle Chute, The, 36-37
Cedar Key Vignette, 2
Center of interest. *See* Focal point
Changes, making, 99-101
Checkerboard, concept of, 19
Chioggia, Italy, 62
Chromatic changes, creating depth with,
 62
Chromatic contrast, directing eye with,
 75
Chromatic gradation, 55
Color
 complementary, 80-81
 general advice on, 80
 of shadows, 83
Color dominance, 48
Color temperature, creating depth with,
 66
Color wheel, 80
Complementary color, 80-81

Condit, William, 47
Corner View, 81, 82
Cove through the Trees, 30
Cropping, 106-107

D

Dancing Mesa, 39
Dancing Rhythms, 48, 105, 128
Depth, nine ways to simulate,
 60-69
Detail, surface, directing eye with, 76
Diminishing repeat, creating depth with,
 68
Directional lines, creating depth with, 67
Docking, Port Manatee, 49
Doggett, Muriel, 47
Dominance, 44-51
Drawing. *See* Painting, vs. drawing

E

Edge changes, creating depth with, 65
Edges, shadow values at, 83
Edifice Mex, 72
Epworth Gate, 68
Exercises
 in adding mid-values, 15
 alternation, 22-23
 linkage, 48
 positive/negative, 34
 in shapes, 31
 in using acetate, 6
Eye, directing
 with accent, 73
 with chromatic contrast, 75
 with human element, 74
 with surface detail, 76
 with value contrast, 72

F

Fall Colors, 41
Falltime Palette, 35
Figures
 adding, to painting, 114-119
 finding hints of, 126-128
 light, adding, over dark areas, 120-121
Fish Houses, 64
Focal point
 adding, to increase scale, 95
 adding interest to, 102
 defined, 70
 placement of, 72, 88

G

Ghost, defined, 120-121
Gisco Docks, 48
Gott, Polly, 66
Gradation
 adding, 88
 creating depth with, 69

types of, 52-59
Greens, mixing, 84
Grouping, defined, 10

H

Hard Place, The, 74
Hidden Cove, 97
Hill Country Ranch, 46
Hill Country Sky, 46
Homestead, The, xii-1
House Remembers, The, 55, 75

I

Inside the Mill, 73
Inspection, The, 107
Intracoastal Panorama, 92-93

J

Jackson Falls, 47

K

Kaiser, R.K., 67

L

La Iglesia, 122-123
Light, reflected, 82-83
Lighting, 112-113
Linear perspective, 60
Lines
 demarcation, in drawing, 24
 directional, creating depth with, 67
 See also Ribbons

M

Maine Morning, 14
Martinique Maison, 29
McGlish, Jerry, 49
Mesa Backdrop, 94
Mid-value, adding, exercise in, 15
Miller, Thomas H., 49
Mist over Jenny Lake, 65
Misty Cove, 76
Monhegan Afternoon, 30
Monhegan Cliffs, 54
Monhegan Light, 55
Monhegan Monday, 39
Monhegan Motif, 8-9
Mountain Stream, 63
Mr. Askin's Porch, 82-83

N

North Carolina Homestead, 85
November Hues, 66

O

Oaxaca Portal, 59
Ocean Point, 15
Oregon Remembered, 10-11